THE NELSON A. ROCKEFELLER COLLECTION OF
MEXICAN FOLK ART

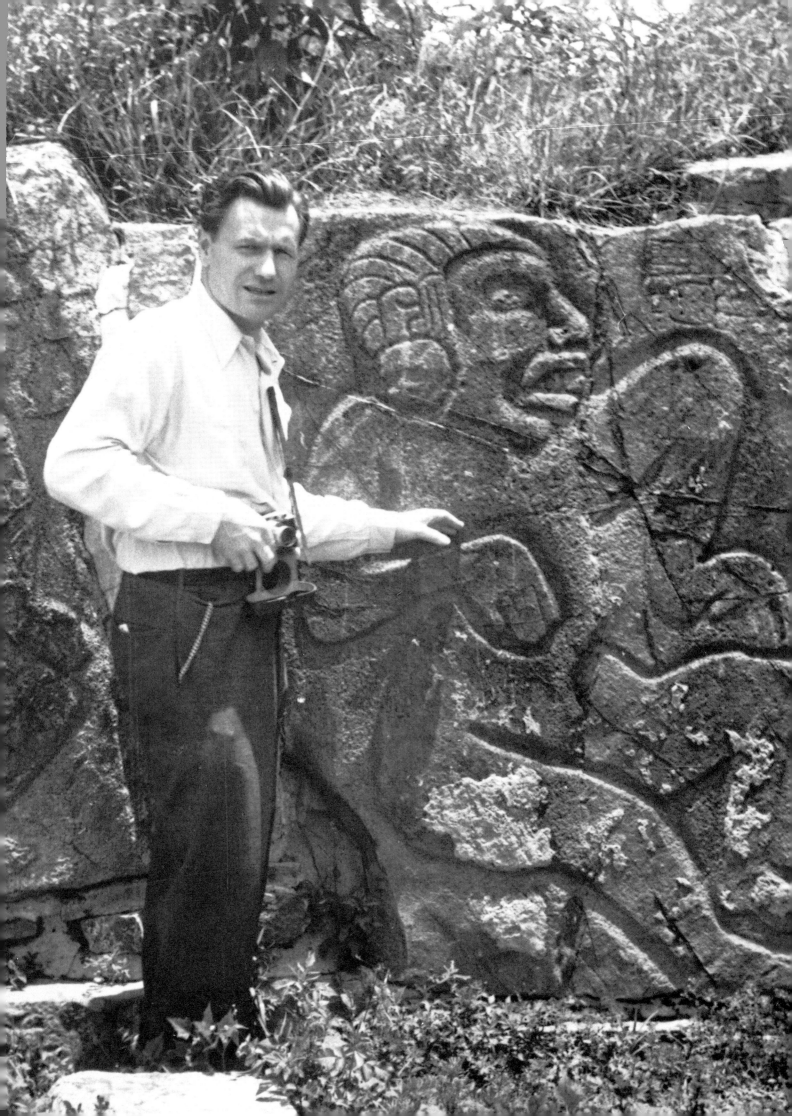

THE NELSON A. ROCKEFELLER COLLECTION OF
MEXICAN FOLK ART

A GIFT TO THE MEXICAN MUSEUM

TEXT BY CARLOS ESPEJEL
WITH CONTRIBUTIONS BY ANNIE O'NEILL
AND ANN ROCKEFELLER ROBERTS

This publication and exhibition made possible
with generous support from El Paso Natural Gas Company through
a grant from Burlington Northern Foundation.

CHRONICLE BOOKS

THE MEXICAN MUSEUM
SAN FRANCISCO

The Nelson A. Rockefeller Collection of Mexican Folk Art
November 8, 1986–March 1, 1987

This publication and exhibition have been made possible with generous support from Burlington Northern Foundation for El Paso Natural Gas Company. Additional funds were provided by the National Endowment for the Arts, a federal agency.

The programs and services of The Mexican Museum are supported, in part, by grants from the San Francisco Foundation, the San Francisco Hotel Tax Fund, the California Arts Council, and the Institute of Museum Services.

Guest curators: Carlos Espejel and Annie O'Neill
Editor: Rain Blockley
Translation from the Spanish of Carlos Espejel's text: Nora E. Wagner
Exhibition and publication artistic consultant: Peter Rodríguez
Photography of the collection: M. Lee Fatherree
Photographs pp. xii, 4, 5: Annie O'Neill
Catalogue design and production: Ed Marquand Book Design

Front and back covers: Lions, by Julián Acero, Santa Cruz de las Huertas, Jalisco (plate 1)
Frontispiece: Nelson A. Rockefeller at Monte Albán, 1933. Collection The Mexican Museum Archives.

The Mexican Museum
Fort Mason Center, Building D
Laguna and Marina Blvds.
San Francisco, California 94123

Chronicle Books
One Hallidie Plaza
San Francisco, California 94102

Printed in Japan

Contents

Acknowledgments

The Mexican Museum is proud and highly honored to have been chosen as the permanent home for a portion of the Nelson A. Rockefeller Collection of Mexican Folk Art. This publication and the exhibition that it documents represent the culmination of an exciting period of growth and public recognition for our institution, a young and emerging national resource dedicated to exhibiting, collecting, and preserving Mexican and Mexican-American art. The process by which this marvelous group of objects has come under our care presents an intriguing perspective on the importance of American philanthropic traditions. These activities have fostered the growth of institutions such as ours, catapulting them into prominence as centers for the serious study of specialized fields.

In the summer of 1984, The Mexican Museum was one of several institutions across the United States under consideration as a permanent repository for the personal folk art collection of the late Nelson A. Rockefeller. This conscientious and thorough search was conducted by Ann Rockefeller Roberts, daughter of the former U.S. Vice President and Governor of New York. With significant foresight, she prevented the dispersal of her father's beloved collection, and by placing it in a public institution, she has ensured its use and accessibility to scholars and public alike for present and future generations.

Although The Mexican Museum was most probably the youngest of all the museums Ann R. Roberts visited during her sojourn, she observed in our institution a vision and commitment toward program goals that she found innovative and dynamic.

Clearly, and with reason, Ann was taken with the chemistry of our organization and the personalities and activities that enable us to fulfill our ambitious and highly worthwhile mandate. Ann R. Roberts has provided a tremendous stimulus to our organization by bestowing her father's outstanding collection; this gift has set the stage for a second decade of growth and evolution for the museum. To our dear friend and *compañera*, Ann Rockefeller Roberts, we extend heartfelt thanks and *abrazos* for the confidence she has shown in our work.

A project of this scope must also include thanks to those individuals who shared their expertise and collaborative skills to present the collection and this publication to the public. Carlos Espejel, former director of the Museo Nacional de Artes e Industrias Populares, Mexico City, has given generously of his time and knowledge to successfully complete the exhibition and publication. Mr. Espejel's essay provides us with a timely contemporary perspective on the issues, trends, and rich traditions that surround this aspect of his country's heritage. His organizational skills and curatorial contributions provided an exceptional educational experience for all who worked closely with him. To Carlos Espejel, our deepest thanks for his warm commitment and faithful dedication.

Annie O'Neill, Nelson Rockefeller's curator and folk art advisor, has provided continual inspiration and professional curatorial advice to our institution since her first visit in 1984. Her insightful essay illuminating her association with Nelson Rockefeller provides a fresh and moving commentary on Mr. Rockefeller's lifetime

involvement with artistic pursuits and his genuine love for the Mexican people, their art, and culture. To Annie O'Neill, we extend *abrazos* and gratitude.

I am particularly indebted to the following friends, colleagues, and scholars who supported our efforts to receive and welcome the collection to San Francisco and helped us to plan for its care and interpretation: The Honorable Mayor of San Francisco, Dianne Feinstein; Ian McKibben White, Director, Fine Arts Museums of San Francisco; Henry T. Hopkins, former Director, San Francisco Museum of Modern Art; Donald North, President, Burlington Northern Foundation; Jillian Steiner Sandrock, Program Officer, L. J. Skaggs and Mary C. Skaggs Foundation; Stephanie Spivey, Administrator, S. H. Cowell Foundation; Andrew Oliver, Director, Museums Program, National Endowment for the Arts; Mark Kasky, Director, Fort Mason Center; Frank A. Norick, Principal Museum Anthropologist, Lowie Museum of Anthropology; Elisa Arevalo Boone, Vice President, Wells Fargo Foundation; Victoria Wood, Program Officer, BankAmerica Foundation; Luz A. Vega, Senior Program Officer, The James Irvine Foundation; Consuelo Santos-Killins, former Chair, California Arts Council; Claire N. Isaacs, Director, San Francisco Arts Commission; David Herod, Principal Curatorial Anthropologist, Lowie Museum of Anthropology; and René Yáñez, Director, Galeria de la Raza.

Finally, a great deal of praise and thanks are due to persons who have lived and breathed this project for almost two years: Peter Rodríguez, Museum Founder and Director

Emeritus, for his aesthetic direction and professional advice on this publication and the exhibition installation; my Board of Trustees, particularly President Fernando de Necochea, for his continual support and advice during two very hectic years; and, last but not least, my staff and our friends who have helped us execute a truly collaborative mission: Nora E. Wagner, Bea Carrillo Hocker, Lorraine García, Rudy Barrientes, Peter Coquillard, Bob Jones, Alida Francis, Gloria Jaramillo, Tomas Ybarra-Frausto, Amalia Mesa-Bains, Henry Wangeman, Ann Barrios, Jeanne Dorinson, Theo Dane, Lee Barish, and Phyllis Rutner.

Lastly, to all those whose names are not listed herein but who have contributed time and energy toward achieving our goals since the museum's inception in 1975, we salute you during this year marking our tenth anniversary celebration.

David J. de la Torre
Executive Director

Foreword

I am delighted that part of my father's collection of Mexican folk art has found a home at The Mexican Museum, an ideal museum for exhibiting and interpreting this fine collection. Founded in 1975 by Peter Rodríguez so that everyone could recognize the contributions of Mexican-Americans and the beauty of their traditional arts, this admirable museum serves its own community and the general public through exhibitions and exemplary education programs. It is a place where Mexican-Americans can and do participate in the study and cultural dissemination of their artistic heritage by working in the museum as staff members, museum educators, and exhibition designers.

The museum is dedicated to collecting all art forms, not just those considered "high" art. The folk art collections are housed alongside pre-Hispanic artifacts, colonial religious art, and modern paintings and sculpture.

Folk art derives its meaning and power from its creators, people who do not necessarily think of these objects as art. They see the ordinary events and rhythms of daily life as worthy of creative energy and artistic embellishment.

Through history, other artists have turned to folk, or so-called primitive, art for inspiration over and over again. They have understood that creativity is a gift, an integral part of our humanness that is expressed through a virtually limitless number of mediums or forms. Creative energy makes no distinction between villages or cities, educated or uneducated, high or low. Artists are channels for its power, and each is given his or her own unique way to express

it. So Teodora Blanco and members of the Linares family partake of that energy as well as Diego Rivera or Henri Matisse.

The folk arts are also a wonderful way to introduce people of all ages to the wide possibilities and uses of creative energy. They eloquently evince the particular habits and attitudes of a given culture, from marriage, child-rearing, and work to death. Wedding clothes, toys, household utensils, ceremonial clothes, and objects—all are richly expressive, full of vibrant color and meaning. Song and dance, laughter and mourning, fiestas and religious celebrations—all have their expression.

My father's dream for this collection can be fulfilled at The Mexican Museum. He passionately wanted folk art to be understood and appreciated by everyone. He wanted folk art to be known as worthy of admiration and study as well as a source of great delight. The collection now can be used to deepen awareness of the cultural heritage and artistic creativity of Mexican-Americans. It can be used as a bridge to build greater understanding and deeper love between the Hispanic and Anglo-American cultures.

Please share with me the pleasure and pride my father would have in knowing that these strong and lovely art objects are now in The Mexican Museum.

Ann Rockefeller Roberts

Preface

When The Mexican Museum of San Francisco asked me to write an essay chronicling the recent history of Mexican folk art, I accepted with great pleasure. During the last eighteen years, I have dedicated much time and energy to studying and promoting Mexican folk art, a topic that I was drawn to long before I began my former government role as director of the Museo Nacional de Artes e Industrias Populares.

To introduce readers to the scope of Mexican folk art, I have analyzed the present situation, current and future government participation, problems confronting Mexico's artisans, and factors in the transformation of many folk arts. Against this background, I discuss the collection amassed by Nelson A. Rockefeller. A series of conclusions includes the sad observation that many of Mexico's traditional folk art forms are rapidly and inevitably disappearing.

My prime objective is to attract the attention of Mexicans living on either side of the border to the importance of traditional folk arts and the need to preserve them. I don't claim to possess the only correct view. Folk art activity has many angles and gives rise to many opinions. Most will agree, though, that these arts represent some of our strongest and most profound cultural roots. For setting this aspect of Mexico's culture before the public, The Mexican Museum is worthy of praise and support.

As folk art disappears, authentic artisans are being lost, dying, distancing themselves from our memory. Many have gone without our having collected their pieces or recorded their names and history. Great because of their works, they have left without being acknowledged. Other great folk artists, such as Candelario Medrano or Pedro Linares, continue to live in almost subhuman conditions.

In recent years, some artisans have obtained public recognition; their works and faces appear in books, magazines, and museums. But what of the anonymous artisans who produce goods for daily use? These, no one remembers. I therefore dedicate this small work to those thousands of men and women who work with only their hands and the most modest materials, and who, during almost twenty years, have allowed me to share a part of their lives, communicating to me the pride of their work and, at the same time, their own skepticism about its survival and their disenchantment that no one will continue their traditions.

Today, when the individuality of work is lost because of the need for industrial processes to satisfy mass consumption, is the opportune moment to notice, support, and rescue the products of these artisans whose work is still useful and beautiful.

Carlos Espejel
Tepoztlán, Morelos
Mexico
May 1986

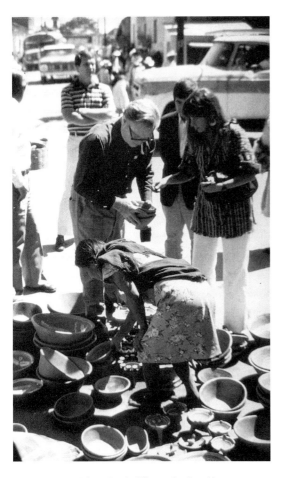

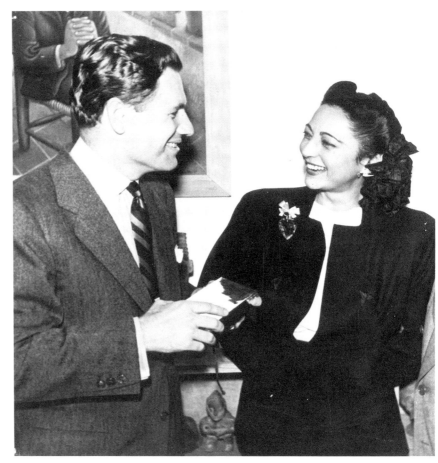

Nelson Rockefeller at the Ocotlán
Friday Market.

Nelson Rockefeller with Rosa Covarrubias.
Collection The Mexican Museum
Archives.

Nelson A. Rockefeller: The Collector

It was always hard to keep up with Nelson Rockefeller; in a Mexican market full of vibrant colors, enticing smells, and profuse activity, it was virtually impossible. His boundless energy and childlike enthusiasm were hard to contain. He didn't know where to look first as he made his way through the crunch of Zapotecans in their weekly market pursuits. The sky was brilliant, the air clear, and the sense of anticipation very keen. It was almost El Día de los Muertos, Mexico's Day of the Dead. Sugar skulls and toy skeletons were everywhere. Rockefeller was ecstatic to be back in a Mexican marketplace after a thirty-year absence. He was about to relive intense memories spanning a forty-five year involvement with Mexico. His happiness was infectious.

Rockefeller was an avid collector of Mexican folk art. From 1933 to 1978 he gathered over three thousand pieces. But why would a man of his background seek out objects from artisans in rural villages and remote marketplaces? Why spend pennies on toy whistles and ikat *rebozos* (shawls) when he could have Etruscan vases?

There is no simple answer. From each of his parents, he inherited different passions and artistic sensibilities. His mother, Abby Aldrich Rockefeller, was a warm spontaneous woman always open to innovation. Her tastes in art were eclectic until the 1920s when her interest focused on modern art. She was instrumental in the founding of New York's Museum of Modern Art (MOMA), which she began to plan in 1928. Her passionate interest in American folk art began in the late 1920s. It was through his mother that Rockefeller developed his lasting affection for folk art.

His father, John D. Rockefeller, Jr., was a serious collector. His passion was very personal and focused on formalism, detail, and precise craftsmanship. He was as devoted to art philanthropy as he was to collecting, a tradition that Nelson Rockefeller would carry on. His great projects included the Cloisters and the restoration of colonial Williamsburg.

Young Nelson Rockefeller grew up against a backdrop of great medieval tapestries, exquisite oriental porcelains, traditional and primitive paintings, and all kinds of statuary. Part of the collection of modern art was hung in the upstairs playroom of the children. His parents always encouraged his enthusiasms for art. Abby told her son that it would be "a great joy to me if you did find you had a real love for and interest in beautiful things."[1]

Nelson Rockefeller attended Dartmouth and graduated Phi Beta Kappa in economics. He felt this was the more practical choice although he studied art in a "kind of dogged do or die manner."[2] After graduating from Dartmouth in 1930 he threw himself into family enterprises of banking, real estate, and philanthropy. That same year Rockefeller married Mary Todhunter Clark of Philadelphia. One of their wedding presents was a nine-month trip around the world. It was on this trip, at the age of twenty-two, that he purchased his first primitive piece, a Sumatran knife handle. This journey opened his eyes to an extraordinary range of people, different societies, and traditional arts and crafts. He met Asian politicians, Mahatma Gandhi, and a gamut of business people. In Bali he met Miguel and Rosa Covarrubias. Miguel, a well-known Mexican artist,

had spent many years in Bali and had written a still famous book on Balinese culture and society. Rosa and Miguel encouraged Rockefeller to visit Mexico.

After returning to the United States in 1931, Rockefeller resumed his activity in various family enterprises. At the same time, his involvement in the art world was growing. In 1932 he became a trustee of New York's Metropolitan Museum of Art and began an active role at MOMA. To justify the time spent at these museums, he told his father that he felt that the aesthetic side of a person's life was almost as important as spiritual development or physical well-being.

In November 1932 Nelson Rockefeller, then very involved in the Rockefeller Center project, helped arrange to have Diego Rivera create a mural for the building's lobby. Abby Rockefeller had been an early admirer of Rivera's work and was instrumental in hiring him. Rivera's sketch was approved and by May 1933 he was working on the monumental project. But when his employers realized Rivera was following his own political blueprint, they halted his work and made plans to remove the mural. Nelson Rockefeller wanted the controversial mural preserved and secured permission to have it installed at MOMA. Tragically, it proved impossible to move the mural without destroying it completely. Rivera reportedly would not speak to Rockefeller for years, although they resumed their friendship some time later.

It seems likely that before the mural incident Rivera and the young Rockefeller would have spent time talking about Mexico. Rivera was

then at the center of a group of Mexican artists and intellectuals trying to promote Mexican popular culture and traditions. Along with other twentieth-century artists, they recognized in the artifacts of ancient and traditional societies a "directness, vitality, abstraction and distortion which linked them to their own art. Modern artists and intellectuals began to endow these former 'curiosities' with aesthetic respectability."[3] At the same time, other Mexicans used pre-Conquest figures for target practice, and paid no attention to the extraordinary traditional folk arts.

Folk art was also threatened by an influx of foreigners. A North American writer visiting in 1931 had a foreboding concern that Mexicans would have to be clever to "preserve their crafts against the southward-moving cloud of dust."[4] North American tourists would soon be able to drive "their Buicks clear through to Mexico City."[5]

On Rockefeller's first visit to Mexico in 1933 to buy paintings for MOMA, he and his wife Mary were introduced to a new world of popular and primitive arts. It began a lifelong passion for him. They also had the good fortune to spend time with people who shared Rivera's love for the popular arts. Miguel and Rosa Covarrubias introduced them to Roberto Montenegro, painter, muralist, editor, and graphic artist; Fred Davis, great collector, folk art expert and advisor, and shop owner; William Spratling, the silversmith who helped revitalize Taxco; and Frances Flynn Paine, an American who had devoted her life to studying Mexican popular arts and who accompanied the two on many village visits. Their friendships were bound

by their love of sugar skulls, imaginatively painted ceramics, and intricately decorated lacquered chests.

His first trip was one of discovery, of suddenly colliding with a magical world that had a very powerful visual and emotional impact on him. He and his wife traveled in great clouds of dust along rutted roads visiting small villages and markets, and wandering in and out of homes. The adventure, *simpatía*, and intimacy he felt with these hospitable villagers totally captivated the young man. He was hooked. He returned home with twenty-six cases of popular art, stone sculpture, and pre-Conquest pieces. His first collection was underway. When he returned to New York, he wrote nervous letters to the shipping company to ensure the arrival of his treasures.

Forty-five years after this trip, he could still vividly recall an afternoon in Tlaxcala with an old weaver or a frantic search for a toymaker in a remote Jalisco village. Mary Rockefeller said, "You never asked 'Why are you buying this bowl?' because there was not always a reason. He just had to have it." The pleasures he derived from even the smallest penny toys transcended the "cult of usefulness and the cult of art."[6] Feelings of joy, sympathy, and love were overlaid on the aesthetic judgments of this beginning collector.

In the mid-1930s Rockefeller met René d'Harnoncourt, a tall, regal Austrian whose eleven adventurous years in Mexico had made him an authority on pre-Hispanic and contemporary Mexican folk art. D'Harnoncourt, who was instrumental in the revival of certain dying folk arts, sought out pieces for tourists and private collectors, and then for the

Mexican government. Eventually he collected folk art for the American Federation of Arts, whose show traveled to fifteen U.S. cities. He became Rockefeller's friend and mentor in this area of art.

As early as 1939 Rockefeller tried to interest the Metropolitan Museum of Art in supporting an archaeological expedition to bring back Mexican art treasures. They had no interest in "primitive" art and flatly refused. Two years later Rockefeller completed his eight-year trusteeship at the Met, but would continue to advocate a change in the institution's attitude toward these arts.

In the same year, as president of MOMA and with the cooperation of the Mexican government, he organized a five-thousand piece exhibition called *20 Centuries of Mexican Art*. It opened at the Museum of Modern Art in 1940. He made certain that folk art was an integral part of this show, and with Robert Montenegro's help, he carefully selected the pieces. The gardens were set up to resemble a Mexican market. Many of the pieces chosen for the show became part of his growing private collection.

In August of that year, Franklin Delano Roosevelt appointed Rockefeller Coordinator of Inter-American Affairs (CIAA). As part of his duty to strengthen hemispheric unity, Rockefeller was to work on enhancing cultural relations with Mexico and Latin America. According to his brother David,

Nelson's experiences in Latin America as CIAA and subsequently as Assistant Secretary of State for Latin America gave him a sense of satisfaction and achievement which, from any perspective, exceeded that which he felt for any of his subsequent activities.

Nelson had a real love affair with Latin America. He felt comfortable with his Latin

friends and his trust and affection for them was clearly reciprocated. Because his feelings were from the heart, he was able to accomplish things of a substantive nature which, with the backing of President Roosevelt, produced a climate of friendship and cooperation.[7]

In 1944 he was appointed Assistant Secretary of State for Latin America. One colleague remembers that in 1945 during the famous Chapultepec Conference to revitalize hemispheric unity, Rockefeller would often disappear at breaks and at lunchtime. He was out seeking new pieces for his growing collection, and greatly excited with his finds, he gave many wonderful pieces away when they were admired by friends or visitors.

Parties at Rockefeller's Washington, D.C., home invariably had Latin American themes. His children dressed in Mexican costumes and mariachis roamed around among platters piled high with tortillas and regional specialties. The host handed out song sheets as people arrived so that everyone could join in and sing in Spanish during the evening.

Rockefeller wanted his children to share his love for Mexico. They learned Spanish at home and later spent summers working on his projects in Latin America. In June 1948 the Rockefellers returned to Mexico for a family vacation. Montenegro, who had become a close family friend, took them far afield to meet new artisans. Rockefeller's daughter Ann remembers going in and out of the homes of artisans—going in empty-handed and coming out with little treasures.

Nelson Rockefeller continued collecting primitive art with d'Harnoncourt, who in 1949 became the director of MOMA and continued

there until 1968, the year of his death. During the 1950s Rockefeller would relax from the demands of his work in Washington by calling and asking d'Harnoncourt to "bring down some stuff," meaning primitive art, of course. Flying in from New York, d'Harnoncourt would meet with the "green and exhausted" politician, who "became visibly refreshed and revitalized during the half-hour picking out the 'stuff' he wanted to buy."[8] Together they hatched the idea of establishing a museum to house the collection—a major step toward realizing their belief that primitive and folk art deserved the art historical acknowledgment accorded "high art." Founded in 1954, the Museum of Primitive Art opened in New York City in 1957. In 1979 its collections were incorporated into the Metropolitan Museum of Art.

Collecting primitive and folk art was for Rockefeller "an enriching experience and a balance to the pressures of business and politics—a constant source of spiritual refreshment and strength."[9] He was reported to be "as exhilarated by the purchase of a work of art as if he had taken a dose of Benzedrene, and a half-hour spent leading an interested observer through his collection leaves him stimulated—and late for the next appointment."[10]

As governor of New York from 1959 to 1973, Rockefeller was absorbed by political life, but his feelings for Mexican folk art were always near the surface. One day in 1968, while driving down 56th Street on his way home from his Manhattan office, he spotted the Mexican Folk Art Annex, my gallery-shop. I still clearly remember this first visit. It was after five o'clock and the shop was closed. When I looked through the peephole

to decide whether or not to let one last person in, I thought I had better let that tired-looking man come in. What a surprise to discover he was the Governor. An even greater treat was to watch him voraciously assimilate everything on all the shelves and in every corner. After a few minutes he looked like a different person—he had been energized. His old interest was alive again.

Soon after this visit, he had all the old boxes in the basement of Rockefeller Center reopened after twenty-eight years. He immediately began planning an exhibition of his Mexican folk art collection for the Museum of Primitive Art. He wanted to update the collection, so I was sent to Mexico in search of contemporary pieces to fill the gaps. When the shipment arrived, he carefully checked every inch of the storeroom, often on his knees, searching for pieces he might have missed.

The 1969 show was exciting and gave him great pleasure. Carl Fox, who curated the exhibition, said it was "a response to a people's life and crafts, where neither names nor status had any influence."[11] It contained all the pieces Rockefeller treasured. The show was a personal triumph in his battle to have folk art recognized in major museums, a battle he still waged with the Metropolitan. He wrote in the foreword to the show's catalogue:

It does not matter if these are categorized as "minor" arts. Artificial categories disappear before works whose vivid color and spontaneous design reflect such pleasure in their making. They delight and fascinate us—and happily let us share in the vitality and love that went into their creation.[12]

Rockefeller continued adding to his collection in the 1970s. He brought

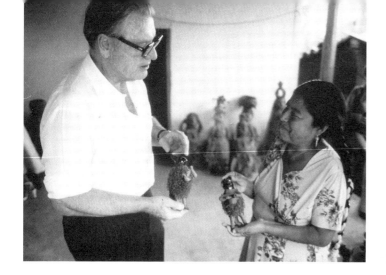

many of his political friends to my shop, always proselytizing. He loved giving Mexican presents to friends and many of his friends and colleagues became folk art aficionados.

During the White House years political responsibilities kept him occupied. In 1977, after his term as Vice-President, Rockefeller returned to New York to the family offices, and in early 1978 he announced he would prepare a series of five books on his personal collections. Since the Mexican folk art collection would be one of these books, a group of us went with him to Mexico that October. Folk art expert Carl Fox suggested the trip, and I made up a strenuous itinerary for our four days in the city of Oaxaca and surrounding villages. Rockefeller invited his daughter Ann R. Roberts and Lee Boltin, the fine arts photographer.

All kinds of officials turned out to welcome Rockefeller to Oaxaca. He was very much a favorite in Mexico. After settling down from the flight, we drove off to see the great ceramic artist Teodora Blanco. Rockefeller expressed great delight as our station wagon forded a stream, narrowly avoiding getting stuck. During the visit itself, he was obviously thrilled to be back in a small village, in an extended family compound with all the attendant activities: animals squealing, children running around, and the smell of fresh tortillas in the air. Teodora Blanco was beside herself with pleasure and pride. That first afternoon in Santa María Atzompa, he bought every figure in her courtyard, from the smallest *músico* (musician) to the largest *muñeca* (doll). No corner was left unsearched. Even her broken pieces were included. He felt her work represented a "subtle

sophistication possessed by but a few of the greatest contemporary artists." [13] He once again felt powerfully moved by "people living and celebrating the quintessence of their heritage in a setting of unparalleled beauty." He sensed what he felt to be "the drama of this endless flow of creativity." [14]

He bought enthusiastically in local markets. Walking into the middle of the dusty Ocotlán animal market, surrounded by bulls and goats and squealing pigs, he purchased an oxen yoke. Later came tinsel-covered candles, Day of the Dead breads, black clay whistles, little orangewood combs, and whatever else struck him with delight. He insisted on taking home great wreaths of garlic and large sisal mats. He bought a straw sombrero and wore it the entire trip. The security men were uneasy as he raced around trying not to miss anything. As one close friend said, he was perhaps the only person who could enter a market on one side and come out the other with five barrel loads. He loved the physical and emotional contact a marketplace is all about.

Rockefeller felt very much at home. He shared tortillas with artisans, a grand supper with the governor of Oaxaca, and ate a fiery *mole Oaxaqueño* in the restaurant La Flor de Oaxaca. His daughter Ann was equally moved by the Oaxaca experience. She always identified with her father's collection—which nobody had seen after 1969 in the years her father was "busy being a politician"— because so many pieces were made by people for whom she too had deep affection. She shared his social conscience, his warmth, and responsiveness to people.

Like her father, Ann feels that really great art has its origins in daily

energies. She responds to creativity whose connections and roots are in the earth, to those "anonymous creators who manage to make art out of almost anything used in their daily lives." [15] That relationship for her is most powerful and at the same time delightful. This trip reconnected her with a period in her life that had great social meaning for her.

We all had an extraordinary time. Our spirits were high and we shared a great camaraderie. In San Bartolo Coyotepec, we visited Doña Rosa to see her working black clay. Rockefeller was covered with great smudges of black kiln residue, but with his shirt sleeves rolled up he went on touching and feeling pottery similar to some of the great pots she made in the late 1930s, which were part of his collection.

It became evident that whenever Rockefeller bought a piece of art, he underwent a very personal experience. For him the object had everything to do with the artisans, their pride and dignity, the transaction and its setting. Each piece produced a joyful memory, its value enhanced by its human history.

He had a photographic memory for these encounters. Occasionally his office would make a frantic call to my store, saying "The Governor was looking at three ceramic dolls he has on his mantel, but he insists he bought five. Can you check that for us?" Sure enough, his visual memory would be right: he had purchased five pieces five years before.

At the home of the Aguilars, artisans in Ocotlán de Morelos, Rockefeller was most excited by ceramic figures, crookedly displayed on a picket fence to advertise this family of potters. He wanted to buy each

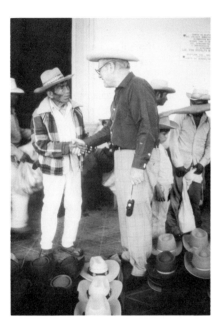

Rockefeller in the Ocotlán marketplace.

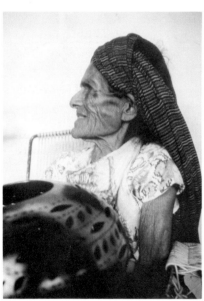

Doña Rosa.

piece. It didn't matter that years in the sun had faded the once brilliant colors to subtle pastels or that various arms were missing; he loved the figures and their expressions. A restorer could always fix a crack.

At the end of the trip, the pieces were gathered and packed in bamboo baskets. An entourage arrived at the airport for Rockefeller's departure only to find him frantically unpacking baskets. Straw was everywhere. The baskets wouldn't fit through the plane's door! It was a hilarious send-off.

We returned to New York eager to begin the book and were hard at work by November. Rockefeller spent a lot of time with us, fussing over the pieces, rediscovering old favorites, and playing with familiar ones. Each time he entered the Pocantico storage rooms he became a child in a candy store. His corn-husk dolls, flying dragons, outlandishly decorated ceramic sculptures, and intricately woven textiles satisfied "a need no less imperative than hunger and thirst, the need to take delight in the things we see and touch."[16]

For him "the excitement of buying and looking at art [was] rivaled by the pleasures of fussing with his possessions."[17] He loved rearranging his pieces, and he had a "great flair for making all sorts of things look good together. All this is an activity and a therapy which he apparently inherited from his mother."[18]

He once said that "art has fulfilled a spiritual need for me. Twentieth-century man is so surrounded by mass production, by machines and anonymous consumer goods, that his eye thirsts for individuality."[19]

At the same time, he was planning a ranch in Texas that would have

been his greatest tribute to Mexican folk art. He wanted to fill it with the work he had collected to reflect the enormous scope of creativity found in Mexico. He pored over old Mexican books with detailed descriptions and illustrations of tile work from Puebla, lacquer work from Michoacán, and colonial wrought iron from Guanajuato. He wanted me to start researching textiles for the upholstery, woven rugs for the floors, and carved doors for the interior. This ranch house would be his "Mexican museum."

Sadly, the project ended before it began: Nelson Rockefeller died suddenly in January 1979. A great tragedy for those who knew and loved him, it was a loss too for those who would have been enriched by the abundance of unfinished projects. Sharing his most beloved collections and pieces with the public was for Rockefeller a constant critical concern. For him a "far more cogent justification for private art collecting than even the benefits it could bring to a wider audience is its importance in international good will. He is at his evangelical best on the congenial theme of the international implication of a respect for art and culture."[20] He was planning to devote the rest of his life to these concerns.

Luckily for all of us, Ann Roberts bought her father's Mexican folk art collection from his estate, preventing its dispersal. Ann realized that this collection should be placed in a museum where it could fulfill her father's dream.

Nelson Rockefeller would have been very happy to know that his collection was being thoughtfully taken care of and being made available to the public. He once said, "Art is a

matter of love. One loves art, and wants to do something about it. Collecting and lending and bequeathing and, come to think of it, building museums to house one's bequests, are the things to do." Although he was unable to assist in the planning of the final homes for one of his favorite collections, he surely would have strongly approved of Ann's decision to give a significant part of the collection to San Francisco's young and courageous Mexican Museum. Its pioneering spirit and idealism are in keeping with Nelson Rockefeller's vision.

Annie O'Neill

Notes

1. Joe Alex Morris, *Nelson A. Rockefeller: A Biography*, (New York: Harper & Brothers, 1960), 73.

2. Ibid.

3. Aline Saarinen, *The Proud Possessors*, (New York: Random House, 1958), 391.

4. Stuart Chase, *Mexico: A Study of Two Americas*, (New York: Macmillan Co., 1931), 188.

5. Ibid., 187.

6. Unpublished essay by Carl Fox, 1978.

7. Claude C. Erb, *Nelson A. Rockefeller and Latin America*, (n.p., Rockefeller Brothers, 1984).

8. Myer Kutz, *Rockefeller Power*, (New York, Simon and Schuster, 1974), 121-122.

9. Francine du Plessix Grey, "Anatomy of a Collector, Nelson A. Rockefeller," in *The Collector in America*, comp. Jean Lipman and eds. of *Art in America*, (London: Weidenfeld and Nicolson, 1971), 13.

10. Saarinen, op. cit., 381.

11. Carl Fox, Introduction to *The Nelson A. Rockefeller Collection of Mexican Folk Art*, (New York: Museum of Primitive Art, 1969).

12. Ibid., foreword by Nelson A. Rockefeller.

13. Unpublished essay by Nelson A. Rockefeller, November 1978.

14. Ibid.

15. "A Conversation with Alexander Girard," in *Multiple Visions*, (Santa Fe: The Museum of International Folk Art Foundation, 1982).

16. Nelson A. Rockefeller, op cit.

17. Saarinen, op. cit., 382.

18. Saarinen, op. cit., 383.

19. Du Plessix Grey, op. cit., 13.

20. Saarinen, op. cit., 394.

Mexican Folk Art
A General Background

The Present State of Folk Art

Artisans in Mexico produce a great variety of folk art at present. But we don't know exactly what or how much is produced, its characteristics, its fate, or its creators and their concerns. This lack of information has impeded efforts to foster and preserve folk art, including programs to support artisans. It also reveals a deficiency in official action.

Meanwhile, more than 1.2 million heads of family—or between 5 and 6 million inhabitants in all urban and rural areas of the country—make their living by producing folk art. The states that produce the greatest volume and variety of these inexpensive hand-made goods are those with large indigenous populations: Oaxaca, Chiapas, Guerrero, and Michoacán. From these communities comes the most traditional folk art, preserved in its characteristic forms, sizes, and colors. Some techniques of this manufacture go back to the ancient pre-Hispanic period.

Highly industrialized states and those without a large indigenous population also produce traditional folk art, but artisans there tend to incorporate more modern characteristics. Thus, Mexico's folk art falls into two large categories: traditional folk art and folk art that we can call new, or modern.

Traditional folk art comprises objects made by simple techniques, in which rural and urban artisans express their ingenuity, dexterity, and creative talent. Rather than separate themselves from the aesthetic and cultural heritage their elders bequeathed them, they become custodians of the purest traditions of their group, their community, and their country. Herein lies the value of these objects. Unlike any other artistic expression, traditional folk art brings together the inheritance, talent, and history of the Mexican people.

Most of these products satisfy social needs: they have utilitarian, ceremonial, ornamental, or purely aesthetic aims. Traditional pottery and indigenous clothing are classic examples. For this reason, I consider traditional folk art the only authentic Mexican folk art, and I believe it must be fostered and preserved for its artistic, economic, and cultural importance.

Modern folk art, on the other hand, includes those objects made by the hands of folk artists in which traditional forms, designs, and techniques are not readily apparent. Or, if these elements do appear, they are combined with modern techniques. Some modern folk art thus has its origin in traditional objects, such as the high-fire pottery of Tonalá, the clay sculptures of Acatlán, the papier-mâché *alebrijes* (creatures) of Mexico City, or the clay "pineapple" jars of Patamban and San José de Gracia. Some call these products artistic folk art, others call them applied folk art. (Applied popular art is the name given by Daniel Rubín de la Borbolla.[1]) These objects lie outside traditional folk art because they are characterized by high cost, new forms, unconventional decoration, and modern manufacturing techniques, functions, and markets. Nor do they need special government protection; their demand is assured.

A second category of modern folk art contains objects some people call Mexican curios. I prefer the term crafts; curios sometimes connotes miniatures, many of which are also made by hand with simple techniques. Crafts, conversely, have nothing to do with traditional folk art.

A multitude of such crafts fill airport stores, markets and stores in tourist centers, and the hands of itinerant vendors. Examples are obsidian and clay idols, Aztec calendars, onyx donkeys, hats decorated with sequins, clowns, and other figures made of papier-mâché, jewelry fashioned from tin, and clothes of modern cut with hand-embroidered detailing.

Production of these crafts does not exclude that of traditional objects; to the contrary, it highlights them. It also provides work for millions of Mexicans. If we need not promote these crafts, then, we also need not denigrate them.

To summarize the current situation, Mexico produces an enormous quantity of folk art, the greatest part of which is traditional and designed to satisfy people's daily needs. Other objects are made for decoration or personal adornment and may or may not be derived from traditional forms.

The two types of folk art, traditional and modern, currently reach production of sixty billion pesos annually, according to El Fondo Nacional para el Fomento de las Artesanías, or FONART (the National Foundation for the Promotion of Folk Art). This is quite an increase since 1979, when FONART put the value of production at ten million pesos, which represented barely 0.1% of Mexico's gross national product.[2]

Aside from employing six million people, this means folk art generates very little income for each artisan, insufficient to satisfy most basic needs. In the middle of today's grave economic crisis, this standard of living characterizes not just the folk art sector. It is the same for all low-salary workers. Many abandon their livelihoods to swell the flow of migrants

to Mexico City or across Mexico's borders.

For those who persist in folk art, the marketing process is well defined. Most artisans sell out of their homes or workshops. Generally, they deal with national or international buyers and federal or state government agencies—such as FONART; the Museo Nacional de Artes e Industrias Populares (MNAIP); and Casas de Artesanías (CASART), which are stores run by some state governments (such as the state of Mexico). Tourists also buy from workshops of the most famous artisans.

Few folk artists sell directly to markets, stores, or tourist centers. The people marketing these goods along Mexico's northern border, for example, are buyers who can afford to acquire large volumes of merchandise, transport it in their own vehicles, and incur the expenses and risks involved with consumer credit. Artisans, on the other hand, live from their work, day to day, and generally receive low prices for their products. Buyers and wholesalers take the lion's share of the end profit.

To obtain higher payment for the artisans is difficult. An intense dependency exists in that buyers often loan money to artisans to control their production and prices. The average artisan has no adequate alternative: government agencies buy only a fraction of the country's folk art production, despite the volume under this category.

Nor does this seem likely to change soon. FONART, the largest government operation related to folk art, reports a buying hike from 1982 through 1985 of 933 million pesos, but this annual average increase of 233 million pesos appears insignificant

in relation to total production. FONART estimates that production grows by 60 million pesos annually. Moreover, FONART's buying decreased slightly during 1985 despite sales that represented the agency's highest profits since 1980.

In my opinion, governmental acquisition of folk art merely reflects good intentions. As FONART indicates, it buys from only fifteen thousand artisans (out of more than a million). Artisans cannot sell their entire production to any government agency, nor are they paid fair prices. Nor does FONART buy from them all the time.

In reality, the government will never have sufficient and timely economic resources to acquire Mexico's folk art production, even of the most well-known artisans. This precludes its controlling the production, quality, and prices of the products. In fact, massive buying by the government is often counterproductive, as official programs demonstrate. When agencies have attempted to promote certain folk art products or acquire quotas from the production of some art centers—be it by pressure from the artisans or with the intent of increasing the production of certain objects—the quality of these items has dropped noticeably. They have then been difficult to market, governmental buying has been arrested or suspended, and the artisans have had to find other buyers at even lower prices.[3]

The low volume of government operations minimizes their impact, and most folk art buying in Mexico remains in private hands. This suggests that the government should perhaps pursue different, more effective ways to promote folk art.

Government Participation

The year 1921, states Alfonso Caso,[4] marks the beginning of an internal awareness in Mexico that the art of our country had important manifestations. The art of the people began to be represented by diverse objects of varied materials and techniques. The enthusiasm of great painters and others interested in folk art—including Diego Rivera, Adolfo Best Maugard, Miguel Covarrubias, Xavier Guerrero, Roberto Montenegro, Jorge Enciso, Alfonso Caso, and Dr. Atl—awakened public functionaries, educated persons, and the popular classes to the taste for Mexican products. They developed various plans to create new respect and interest in genuine Mexican folk art.

The first official act promoting folk art in Mexico and abroad was a 1921 exhibition in Mexico City commemorating the centennial of Mexico's independence. The displays included pottery, lacquerware, glass, textiles, and other materials organized by Enciso, Montenegro, and Atl. Atl's book on the show, *The Popular Arts of Mexico*, was published by the Secretariat of Industry, Commerce, and Labor and became the main reference on the subject for many years.

Many governmental attempts followed to display the richness of Mexico's folk art before the eyes of the world. Exhibitions toured Brazil and Argentina in 1922, comprising objects from the centennial show. Under the auspices of the Secretariat of Industry, Commerce, and Labor, another show in 1922 traveled through the United States and various European countries. In Mexico City in 1934, the Palace of Fine Arts held an exhibition, and in 1940 the Museum of Modern Art (MOMA) in New York City produced a show.

Each of these included a large number of objects and were truly representative of Mexico's folk art.

MOMA's 1940 exhibition helped to open the North American market. The event and its catalogue generated much interest in Mexican art among the general public of the United States. The show's organizers, MOMA and the Instituto Nacional de Antropología e Historia, later published a book in English and Spanish titled *20 Centuries of Mexican Art*.

Among other government attempts to promote folk art during these early years was the creation of the Regional Museum of Pátzcuaro, in 1938, launched by Mexico's president, Gen. Lázaro Cárdenas. Among efforts by foreign groups, both private and nonprofit, the American Federation of Arts organized and sent a notable exhibition to several cities in the United States in 1930–31.

Stronger measures publicizing folk art began in the 1950s. Credit for the most important one belongs to Alfonso Caso, who, as director of the Instituto Nacional Indigenista (INI), helped establish the Consejo de las Artes e Industrias Populares (Council on Popular Arts and Industries). One of its first acts was to found the Museo Nacional de Artes e Industrias Populares (MNAIP). Almost simultaneously, the council created various regional museums: the Pottery Museum in Tlaquepaque; the Museum of Huatapera, in Uruapan; and the Lacquer Museum in Chiapas de Corzo. For twenty years, MNAIP provided guidelines that led the way for opening the national and international markets to folk art.

The year 1961 saw the creation of the Fideicomiso para el Fomento de las Artesanías, a trust for the fostering

of folk art, which became FONART in 1974. The Dirección General de Culturas Populares was created in 1971, and the new Museo de Culturas Populares opened more recently.

In the early 1970s the promotion and merchandizing of folk art reached an important level, facilitated by a sympathetic government policy. This gave rise to its widespread acceptance by large sectors of the population, principally in Mexico City. People who previously had no knowledge of these goods, in part because they had never been so readily available, now immersed themselves in the effervescent environment created by folk art. Even government agencies unrelated to the arts took an interest, purely to court official favor. More significantly, the once indifferent middle class quickly began buying folk art. This authentic process of reevaluation continues to the present, albeit less intensely during the current economic crisis.

This internal rediscovery of folk art and the demand generated by tourists motivated artisans to increase production dramatically during the first five years of this decade. Even so, demand caused prices to rise, especially for several artisans who became famous at the time, such as Herón Martínez Mendoza, Dámaso Ayala, Francisco "Chico" Coronel, and the Linares family.

The surge in output continued throughout the administration of President Luis Echeverría, from 1971 to 1976. As one means of resolving the nation's economic problems, his government focused extraordinary attention on folk art. But the next administration, while it did not suppress folk art, gave clear indications of rebuffing it. Now, ten years after

Echeverría stepped down, the situation is no better. An almost total indifference exists and official participation in the arts is minimal. Of the fifty government agencies that bought, promoted, exhibited, or were otherwise related to folk art during the first half of the 1970s, the only ones still active are FONART, MNAIP, the Dirección General de Culturas Populares, and a few state organizations. They control the only government resources directed toward the folk art sector. The economic crisis, which entails constant adjustments and spending cuts, threatens to reduce this already meager category. FONART manages smaller volumes of buying, has cut back its staff, and has limited its promotional activity since 1985.

Policies promoting folk art are part of Mexico's general plans for economic development. The principal organizations described below are charged with implementing these policies and activities.

FONART's main goal is to reevaluate, preserve, and disseminate Mexican folk art and to strengthen the economy of the Mexicans who produce it. Specifically, its objectives are: to gain a higher family income for artisans; preserve the artistic nature of folk art; buy, exhibit, and market products; grant credit and advances to artisans; provide them with technical and administrative support; and design and develop art projects for production.

Similarly, MNAIP's goal is to exhibit folk art to the public, disseminate its use, improve production techniques while respecting the artistic inspiration of the producers, and increase artisans' income.

Obviously, both organizations have identical functions. This was jus-

tified at their inception, but now, after more than a quarter-century (MNAIP celebrates its thirty-fifth anniversary in 1986, FONART its twenty-fifth if one counts its immediate antecedent), it is appropriate to ask whether they have accomplished their objectives.

These two agencies have been beneficial, though only partially so for the artisans and their work. Their intense promotional campaign for folk art has helped create an awareness of it in many consumers, domestically and internationally. Their sale centers, exhibitions, studies, and publications are valuable contributions toward the future of contemporary artisans, some of whom have also profited by sales to FONART and MNAIP. Some of their competitions and prizes have stimulated artisans to upgrade their work, and experimental workshops have provided technical assistance.

Thus, FONART and MNAIP have each achieved their ends, to some degree. The funds they manage, however, limit their action from benefiting a larger number of artisans. Also, their policies of research, promotion, and marketing prevent them from acting efficiently, following and coordinating common goals instead of independent and sometimes redundant ones.

A proof of this lack is that, after sixty-five years of official action and more than twenty-five years since these organizations began, no museum of folk art exists commensurate with the cultural richness of Mexico. Nor is there a museum that exhibits the different branches of Mexican folk art and collects work by the most qualified artisans. No catalogue is devoted to the best folk art produced, or folk art appropriate for mass marketing.[5]

The most sensitive issue, however, is that no one has enacted a policy to stop or even slow the disappearance of traditional folk art forms. One by one during the last thirty years, folk art forms that were an important part of Mexico's cultural heritage have been lost.

Folk Art in Transition

As traditional folk art disappears, Mexico loses a part of its popular culture, its history, the talent of its people. This is lamentable, especially now, when it is absolutely indispensable to maintain the integrity of our cultural identity. The loss of this art reflects a reversal of cultural currents, a contempt of all we once considered valuable, useful, and distinctive.

Various factors directly affect traditional folk art, causing forms to vanish sooner or later. Among them is the scarcity or lack of certain natural raw materials, such as particular clays, shake wood, palm, *aje* (the by-product of a particular worm, often used in the production of lacquerware), and the cochineal and sea snails used to make dyes. Another factor is government prohibitions against importing materials such as porcelain beads, vermilion for lacquerware, and rabbit fur for the traditional *charro* hats. This has changed the quality of some objects and caused others to become extinct.

The gradual obsolescence of certain ancient forms has given way to products more in keeping with the requirements of modern life. With the progressive industrialization of certain areas, other folk art has disappeared because the people who produced it now work in factories or other businesses. Young people are reluctant to dedicate themselves to folk art activity; studies show that artisans'

children abandon their trade in favor of schooling. Some artisans also forsake folk art due to the low prices of many traditional objects, such as popular pottery. In many folk art centers, only old people remain, and some of them are there solely because they can no longer do other, salaried work.

Ultimately, though, the greatest factor in the loss of folk art is the attrition among elderly master-artisans who take with them certain forms, designs, or secrets about preparing their materials. With each such death, Mexico loses not only a traditional folk art and an artisan, but also an irreplaceable fraction of folk culture. Nothing can be done to prevent this, and we lament the fact that no one can ever again create the clay dolls of Teodora Blanco, the pots of Doña Rosa, the little roosters of Nicolás Martínez, or the miniatures of Angel Carranza.

Although folk art will not vanish from Mexico altogether, fewer traditional objects appear in the folk art inventory every day. We may be observing the last or one of the last generations of artisans who truly know the process and context of folk art. Do what we may, certain traditional arts will disappear irrevocably. Others will come along, as happens now, but those that in their day fascinated us by the beauty of their forms, their charm, their simplicity, their attention to decorative detail, or the ingenuity of their mechanisms—these are ebbing away forever.

Folk art not only disappears, it also changes. It is modified and renewed so rapidly that some objects acquired twenty years ago now seem centuries old. Like a society that changes constantly, folk art follows a natural evolution. This is not a recent process,

nor is it particular to our day. Folk art has always adapted to the tastes and necessities of each era. As Daniel Rubín de la Borbolla states, "Man does not produce anything that is not useful to his immediate culture, his daily life and the life of others."[6]

An extreme case in point is the brutal transformation experienced by the folk art of ancient Mexico after the Spanish Conquest. Some disciplines vanished, such as featherwork, which had no use in colonial life. Others, such as pottery, adapted new techniques and forms to satisfy the demands of inhabitants of New Spain. Ironwork, leatherwork, and glass, unknown in Mexico during the first half of the sixteenth century, were among the novelties that entered Mexico's traditions after a long, hard, and, I would say, loving process of change. Three hundred years passed as artisans tempered these media to their taste and sensibility, gradually turning them into authentic underpinnings of the culture.

Today's transformations are more rapid and therefore more apparent. We have greater knowledge of folk art and its producers, so we are more sensitive to changes. Variations in certain raw materials—clay, for example—have affected potters in Tonalá, Tlaquepaque, Izúcar de Matamoros, and other locales. In Tonalá, which has long been Mexico's most important clay production center because of the beauty of its work, potters in ancient times had access to clay deposits of excellent quality. As time went on, these deposits were covered over by urban development. Since then, artisans have had to use different clays, changing the thickness and weight of their pottery.

Similarly, natural pigments for dyeing the wool and cotton thread used in textiles are not readily available. For a time, artisans substituted imported pigments. Now such imports are banned, and the domestic dyes are not as good.

Another factor is tourism. Alien to the traditional character of Mexican folk art, foreigners buy what they see in stores, what is offered them, what fits their budget; they do not always distinguish between what is traditional and what is not. But tourists are also not obliged to know what is traditional. They cannot be blamed for being offered prostituted articles.

Professional buyers also influence changes in some objects. In the case of polychromed pottery, they suggested using oil- or vinyl-based paint instead of aniline-based. These substitutes don't leave paint on one's fingers as one touches the pieces and won't spoil if it rains at an open market. For the same reason, some pottery is now glazed.

Some buyers, including government agencies, have factored in quality changes: refusing to pay artisans higher prices encourages them to finish their pieces carelessly or to utilize materials of inferior quality. And requesting objects other than an artisan's habitual products has also precipitated change.

Nonetheless, a natural tendency of artisans toward innovation plays a far greater role in folk art's evolution than tourism, buyers, or government programs. Pressured by necessity or market characteristics, artisans introduce the most significant changes in their wares. Parallel to or supplanting the production of traditional forms, new creations arise each day, principally among potters. In this way

they try to maintain their source of work and increase their income.

Artisans thus abandon much of their traditional folk art, particularly utilitarian goods, in order to produce luxury items for decorative purposes. These bring higher prices, naturally. The clearest example is in Ocumicho, where artisans originally shaped toys by mold for sale at town fairs in the Tarascan plateau. Today, these molded toys have almost disappeared in the wake of expensive decorative pieces. These new forms were first produced as a result of the inspiration of a member of that community, Marcelino Vicente, and later because government agencies fostered the innovation.

Traditional forms are thus being lost little by little, and new ones are produced in ever greater numbers. Change is the option of survival for the artisan, at times the only one. It cannot be avoided.

Other artisans increase production to obtain incomes that satisfy their own family needs. Previously, artisans could dedicate many hours and even days to the manufacture of an object or a lot of objects, knowing they could wait for market day, the *tianguis*, or fair, to sell their products. Today, clients come to their homes in search of art, and the artisans lack time to produce enough to meet the demand. They put their children and other people to work, and partly from lack of practice, partly inventiveness, these assistants introduce changes to forms and decoration.

Artisans also copy and reproduce objects they see in magazines or other media or which customers suggest. This cannot be avoided, of course. Mexican artisans demonstrate a natural receptivity, and it would be impossible to isolate them from external influences.

In this manner, each generation of artisans changes objects and introduces models from its surroundings. Some are successful, others detract from the quality or the traditionalism of folk art. Generally, artisans make changes in response to inspiration or to resolve technical problems according to their expertise, more than in response to foreign influences. Imposed change, on the other hand, usually results in failure.

Change is not only inevitable, in certain cases it is absolutely necessary to increase production and sales, fill orders for export, or avoid excessive work in particular phases of production. It is also necessary to root young artisans in the work of their elders, to prevent certain folk art from being lost or no longer produced.

This change must be directed, supervised, and conscious because even suggestions by the most learned or well-intentioned person signify sometimes irreversible—often unfortunate—effects on folk art. In Metepec, for example, artisans still remember Diego Rivera's influence on the coloring of the ware. And in Tonalá, vestiges remain of Aztec-like fret designs imposed by Dr. Atl. Fortunately, local artisans have undertaken to rid themselves of these particular interventions.

How can change be supervised appropriately? If folk art continues to disappear without recall, if the artistic quality of traditional objects is not respected, if we have not been able to increase artisans' income, extend credit to them, or offer them social security, if they continue to live in unhealthy, marginal conditions of poverty, what official action remains?

Recommendations

While the government has taken some positive action to alleviate the diverse problems facing folk art—lack of documentation, inadequate promotion abroad, limited technical assistance, to name a few—it has not done so as part of a long-range plan. Preference has been given to buying, selling, and exporting folk art objects as a means of helping artisans. But I am not convinced that this is the best way to protect folk art and its artistic quality. Instead, the government must define a broader perspective. The country needs general programs of continuous action, a definition of what has to be promoted, rescued, and marketed. It needs criteria for deciding which objects must be preserved as they are, with their traditional forms, designs, decorations, and techniques of manufacture by hand, and which can be changed or produced industrially for sale on a larger scale.

A long-range program, of ten years or more, might include a census of artisans and folk art by states, which could simultaneously serve as a folk-art/tourist guide; the clear and precise definition of those folk art forms that require study, support, rescue, or promotion; the compiling of collections that contain the best samples of present-day folk art; the foundation of folk art museums in strategic locales, folk art communities, and tourist centers; and the production of films, slides, audiovisual programs, and publications to gather data on Mexican folk art and serve as tools of dissemination, study, and promotion.

Government action need no longer concentrate solely on promotion and marketing, given the reality of today's market. Efforts to create an awareness of folk art and disseminate its use,

undertaken in the 1920s, are no longer a priority. Instead, official programs should focus on the study and preservation of folk art. National folk art catalogues would help in this and other respects. No artisan keeps samples of production, and only a few have any photographs of their works. A series of catalogues could describe the main traditional folk art produced in each state of Mexico; another could deal exclusively with those objects suitable for export on a large scale. The Dirección General de Culturas Populares and the Museo de Culturas Populares could actively participate in this.

Some will say that shifting government support from buying and exporting to study and preservation would leave a fair number of artisans without a market. But given the scarcity of government resources available for the folk art sector, a choice must be made. It is more likely that the private sector will directly support the artisans through purchase than take an active part in studying and preserving this national tradition.

Folk Art Collections

Before the inevitable loss of some folk art forms and the evolutionary change of others, before the disappearance of the remaining master-artisans, it is imperative to form folk art collections. In this way, future generations will know them and appreciate them. These collections will also serve as stimuli and guides so that new objects can be produced to be as useful and attractive as the ones we now know.

In Mexico, there have been and still exist very important collections belonging to Mexicans as well as foreigners, among them the collections of: Fred Davis, acquired by MNAIP;

Franz Meyer, soon to be in a museum, which contains many samples of antique folk art; Roberto Montenegro, installed in the School of Design and Crafts; Luis Márquez, whose extensive accumulation of indigenous clothing is now in the Cloister of Sor Juana Inés de la Cruz; and the masks and clothing of Donald and Dorothy Cordray. These collections are some of the earliest and best known.

Among the newer collections are those of Ruth Lechuga and Teresa Pomar. Among those that have been lost to Mexico and sold abroad is that of Jorge Wilmot. It is the only collection that was amassed with a precise idea of folk art's importance to the identity of the Mexican people. Various components project a clear image of the Mexican from pre-Hispanic times to the present, passing through colonial Mexico, independent Mexico, and postrevolutionary Mexico.

In other words, one finds pieces of the pre-Hispanic era that are repeated in contemporary work of Ocumicho, for example. Metepec still produces other goods that are identical to objects from the colonial period. This persistence of forms, themes, and artistic tendencies mirrors with clarity the face of Mexico, its history, art, and culture.

Like Wilmot, many foreign and Mexican collectors sell or bequeath their folk art abroad. No museum in Mexico can house and preserve these collections, so would-be donors are afraid their art might be lost or dispersed. Many collections have thus reached North American museums, where they are cared for, catalogued, conserved, and exhibited. Such is the case with the folk art amassed by Nelson A. Rockefeller.

The Rockefeller Collection

In the spring of 1979 Nelson Rockefeller asked me to write a text on his collection, and we discussed promoting its exhibition in the United States and Mexico.[7] When I first saw the collection, I was surprised not only by its size but the artistic quality of its objects. The largest portion comprises pieces of pottery, demonstrating at once the collector's sensitivity toward this ancient art. There are also splendid textiles, examples of popular religious painting, masks, objects of glass and wood, lacquerware, sculpture, and toys.

While I studied the pieces, some of which are quite modest, I asked myself how a man like Rockefeller came to have such an interest in Mexican folk art. He answered this query himself in a text he wrote on Mexican art. In warm lines, Rockefeller describes his first visit to Mexico in 1933, when he came in contact with Mexicans and their folk art during his forays through the country's interior. Certainly these initial encounters were enhanced by the friendships he established with the great painters of that time, among them Rivera, Montenegro, and Covarrubias. By then, as noted, these artists had become active promoters of folk art.

All this contributed to Rockefeller's great fondness for Mexican folk art. Interest grew during his later visits, until the last one, in October 1978, when he returned to the state of Oaxaca during the Day of the Dead festivities. His collection now includes objects acquired during this trip: several clay dolls of Irene Aguilar, from Ocotlán de Morelos; others of Teodora Blanco, from Atzompa; as well as papier-mâché *alebrijes* from the Linares family, in Mexico City.

Rockefeller stated the profound interest he had in these artisans and

their products as well as the emotion he felt toward Mexico, its people, traditions, and art—sentiments reflected in the works he gathered during the forty-five years after his 1933 visit. He also described an encounter during his first visit: he met an indigenous weaver whose production of sarapes (blankets) he bought almost in its entirety—fortunately so, because as he explains, no young person would later have the patience to learn to make them the same way, nor did he ever again find anything that compared with the beautiful work of that woman. This anecdote clearly expresses the practical sense of the collector, who realized certain folk art is inevitably lost through the years when its producers disappear.

After seeing and studying the most important pieces in the collection again and again and writing extensively on them, I can say that the artistic quality of the objects is remarkable. The collection constitutes a testimony to Mexican folk art of the last half-century. Many of the objects are no longer produced; others serve as bases for comparison with what is made now, illuminating the changes during this century. The collection thus validates what this essay has presented on the reality of folk art. It also confirms the importance of such collections.

Careful review of the Rockefeller collection reveals no system in its composition. He did not collect only certain art forms or from only a few artisans. He acquired objects that attracted his attention because of their artistic quality. In 1933, for example, when he met Mardonio Magaña, that extraordinary sculptor discovered by Diego Rivera, Rockefeller was awed by his talent and acquired various examples of his art. In his text, he mentions seeing Magaña's sculpture in a park, being attracted by its sensitivity and aesthetics, and visiting his workshop to purchase the pieces.

If no system guided his acquisitions, however, Rockefeller followed a sense of artistic vision in selecting good work. This vision allowed him to assemble a very valuable group of Mexico's most genuine folk art. Those pieces now in The Mexican Museum are representative of the whole collection. The pottery of Jalisco, Guanajuato, Oaxaca, Guerrero, Michoacán, and Puebla predominates. Included are pottery for both domestic use—pots, jugs, pitchers, plates, and zoomorphic banks—and for decorative use, such as the beautiful dolls of Teodora Blanco.

Among other art displayed are utilitarian pieces of glass and lacquerware from Olinalá, Pátzcuaro, and Uruapan; ritual objects such as candlesticks, and *copal* and other incense burners; various figures expressing fantastic imagination, including a group of wooden masks; and finally, indigenous clothing.

Conclusions

Folk art activity enjoys particular economic importance in Mexico because, according to the most trustworthy estimates, eight percent of the population—one in every twelve people—depends on the production and sale of folk art. Current production can be divided into traditional and modern folk art. Both satisfy extensive social needs and the demands of tourism, but because of its form, size, color, decoration, media, techniques, and historical significance, traditional folk art represents the genuine folk art of Mexico. Much of this art is being lost because of factors difficult to control and resolve. As a result, Mexico is losing part of its cultural estate.

Despite folk art's economic and cultural importance, government action undertaken twenty years ago and perpetuated until now has been insufficient and ineffective in impeding the loss of art forms and improving artisans' living conditions. Government intervention needs a new orientation so that, during the next several years, it can help preserve traditional folk art.

One such action is to amass folk art collections such as exist in the hands of private individuals in Mexico and abroad, of which the Rockefeller collection is a good example. Especially as time goes by, these become invaluable cultural legacies, prodigious sources of information about the traditions, history, arts, and life of the Mexican people. Today we can enjoy the Rockefeller collection; perhaps tomorrow many more such treasures will be preserved.

Notes

1. In Porfirio Martínez Peñaloza, *Tres Notas Sobre el Arte Popular en México*, (Mexico: Miguel Angel Porrúa, 1980), 15.

2. Rodolfo Becerril Straffón, "La Importancia Económica y Social de las Artesanías," presented at a seminar on the problems of folk art, (Mexico: FONART-SEP, 1979), 21.

3. Between 1982 and 1985, FONART reached national retail and wholesale sales of 1.611 million pesos, an annual average of 403 million. Simultaneously, its exports of folk art rose to 46 million pesos, or 11.5 annually. We don't yet have statistics for its 1985 exports, but official data for 1977 puts exports at 4 million pesos (Rodolfo Becerril Straffón, "La Importancia Económica y Social de las Artesanías"; Mexico: FONART-SEP, 1979; 21). Obviously, government exports diminished in the ensuing seven years.

 On the other hand, FONART's national retail sales from 1980 to 1985 show a notable increase, from 77.8 million to 585.2 million pesos, an apparent six-time rise in six years. Of course, the 1985 figure reflects price changes since 1982, when inflation began to skyrocket. Thus, the added 507.4 million pesos since 1982 may not be so important at second glance.

 Finally, though FONART's domestic sales exceed its exports, internal consumption of modern folk art is not necessarily greater. Government entities lack the structure, tools, capabilities, and determination to export optimally, and I estimate that while a good portion of Mexico's modern folk art is exported, directly or indirectly, most traditional products are sold internally.

4. Alfonso Caso in his prologue to *Bibliografía de las Artes Populares Plásticas de México* 1:2, (Mexico: Memorias del INI, 1950), 83.

5. Nor has anyone updated the catalogue initially written around 1963 and published as a special edition of the magazine *Artes de México* by the Patronato de las Artes e Industrias Populares for INI under the auspices of Petróleos Mexicanos and other government entities.

6. Daniel Rubín de la Borbolla, "Conservación, Protección, y Fomento de las Artesanías," (Mexico: FONART-SEP, 1979), 73.

7. Because of Rockefeller's untimely death, this project was curtailed.

Catalogue of the Exhibition

To illustrate this catalogue, we have selected the most beautiful of the donated objects in the Nelson A. Rockefeller Collection of Mexican Folk Art. Although we have given preference to traditional forms, we have also included pieces that illustrate points made in the foregoing essay. The objects appear in eight groups: man and woman, the fantasy of the artisan, toys, ritual objects, ceramics, glassware, lacquerware, and clothing.

Each photographed object is identified by the name given by its producer. The piece's artisan, provenance, and description are listed if possible, but such information is not always available. The items date from the turn of the century to 1978, when Rockefeller last visited Mexico; accession numbers appear after each item's measurements.

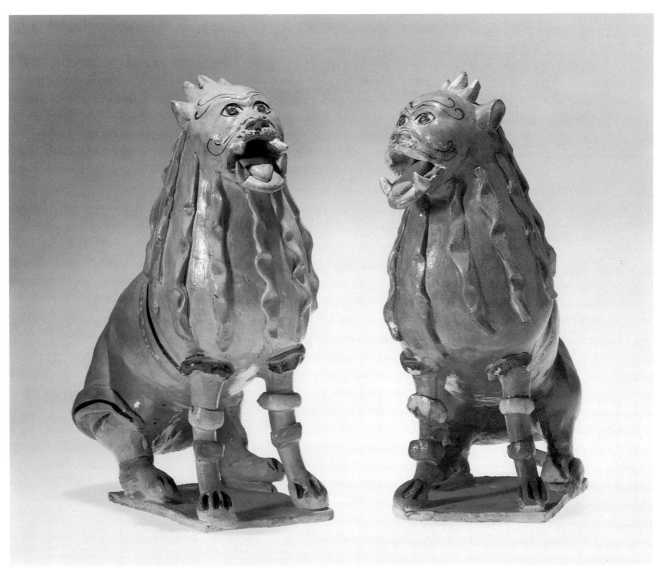

1.
Lions
Julián Acero
Santa Cruz de las Huertas, Jalisco
Clay: formed on a traditional mold, appliquéd, single-fired, brush-painted with aniline dyes that have been dissolved and heated in alcohol, and varnished
Left to right:

33 × 22.5 × 12.5 1985/1.277 E
24 × 19 × 10 1985/1.313

Among the most beautiful pieces in the Rockefeller collection, these lions reflect the aesthetic sense of an extraordinary ceramist. Thin strips of pinched clay make up the animals' manes and give greater volume to their chests. Equally notable are the spikes on their heads and the rings on the front paws. The faces have human features similar to those of ancient *naguales* (mythical guardian spirits). Pieces with such well-defined facial expressions are difficult to find today.

Figures such as these generally rest on a rectangular slab of clay to protect their fragile extremities. The base and body are made of fine clay that is now scarce.

Man and Woman

The human figure is a favorite theme of artists worldwide. These anthropomorphic figures, made principally of clay, demonstrate the dexterity of Mexican artisans. Created with great attention to detail, these lovely objects also exemplify the physical types, clothing, personal adornment, and customary activities of the people who served as models.

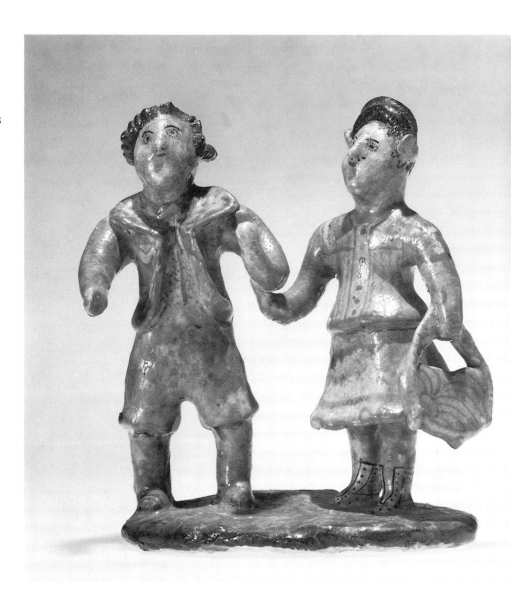

2.
Pair of figures
Flores family
Izúcar de Matamoros, Puebla
Clay: hand-modeled, single-fired, brush-painted with aniline dyes dissolved in water (over a base of white engobe), traditional polychrome finish, high-gloss varnish
5.2 × 12.7 × 7.7 (avg.)
1985/1.13

3–4.
Fruit vendors
Panduro family
Tlaquepaque, Jalisco
Clay: formed on a traditional mold, refined
by hand, single-fired, brush-painted with
aniline dyes dissolved in water
17 × 12.5 × 10 (each)
1985/1.159 A–B

Figures such as these represent market
vendors and are used to adorn crèche
scenes during the Christmas season.
From the beginning of November,
the artisans and merchants of Tla-
quepaque, the production center for
this work, install themselves in a large
market in Mexico City to sell the fig-
ures they have made during the year.
Some are quite outstanding. Artisans
such as the famous Panduro family
are true portraitists of their time.

In this type of folk art one can see
the changes that have occurred over
the last fifty years. Colors were for-
merly created with aniline dyes and
applied by brush; now industrial-type
vinyl paints are applied with air guns.
Artisans no longer use egg yolk to fix
colors, and traditional molds are dis-
appearing. Little by little, grotesque
figures replace the traditional ceramic
ones.

Perhaps the customs of Mexico
City's inhabitants, who prefer Christ-
mas trees of Nordic origin, are a fac-
tor. Their city is the most important
market for these figures, but demand
diminishes each year.

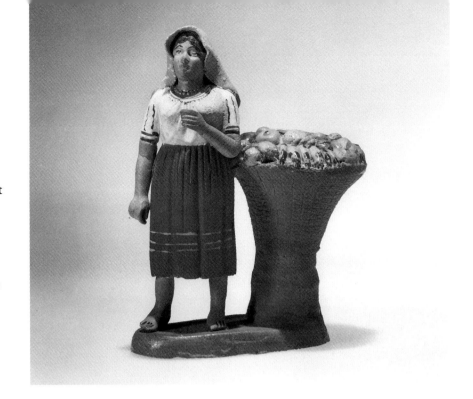

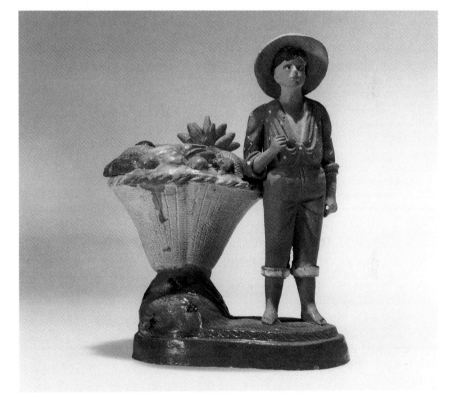

5.
Dolls
San Cristobal de las Casas, Chiapas
Wax and cloth: hand-modeled
15 × 13.5 (avg.)
1985/1.11 A–D

The bits of cloth dressing these dolls
reflect the attire of Chamula Indians
in the mountains of the state of
Chiapas.

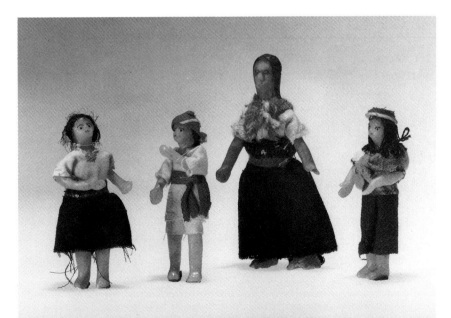

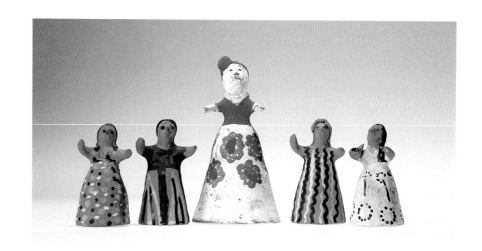

6.
Dolls
Ocotlán de Morelos or Juchitán, Oaxaca
Clay: hand- and moldmade, single-fired,
painted with aniline dyes and oil paints
15.2 × 7.5 (large doll)
1985/1.161 E, .220 A–D

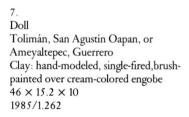

7.
Doll
Tolimán, San Agustín Oapan, or
Ameyaltepec, Guerrero
Clay: hand-modeled, single-fired, brush-
painted over cream-colored engobe
46 × 15.2 × 10
1985/1.262

This unusual doll is decorated with
floral motifs brush-painted in red
tones that contrast with a cream back-
ground. Potters call this style of deco-
ration "natural"; it is being
abandoned by today's artisans in
favor of strong coloring and high-gloss
varnish.

The doll is a good example of the
ceramics of the towns of Tolimán,
San Agustín Oapan, and Ameyal-
tepec, in the central zone of the state
of Guerrero. Such work gave rise to
another form of folk art now com-
mon throughout the region: painted
amate (bark paper, produced in San
Pablito, in Puebla's northern moun-
tains). Years ago, potters began paint-
ing flat surfaces, principally *amate*,
with the same floral and animal
designs they had produced on clay.
Entire towns that had never worked
in clay now paint on *amate* in the
same style.

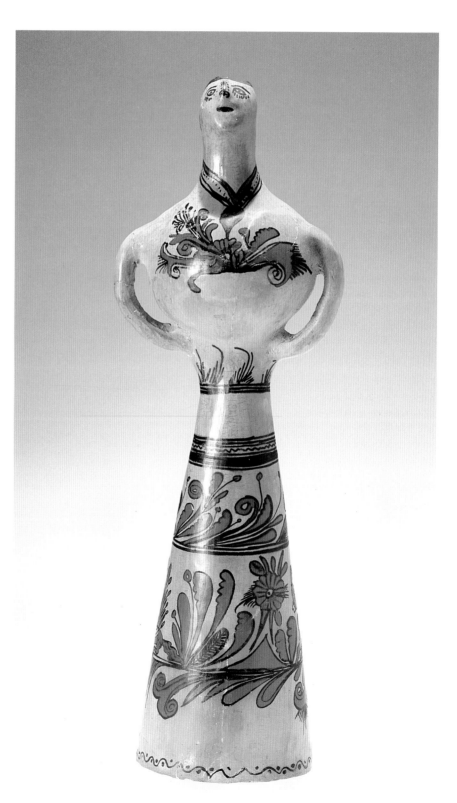

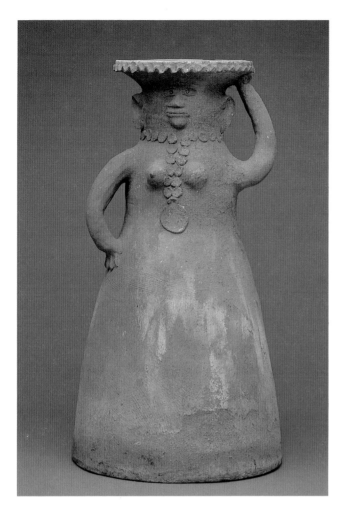

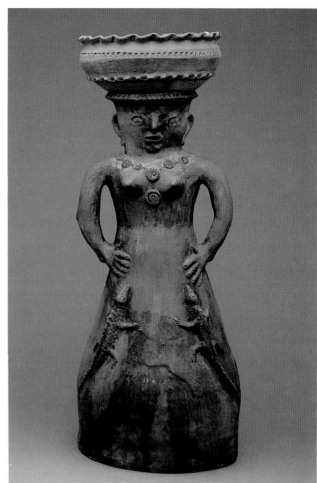

8–9.
Anthropomorphic basins
Isthmus of Tehuantepec
Clay: hand-modeled, single-fired
73.5 × 33 × 35.5 (avg.)
1985/1.190 A, C

These water-cooling basins tradi-
tionally consist of three parts: a doll;
on her head, a bowl of damp sand;
and, on top of this, a pot used to store
the family's drinking water. Pots are
sometimes adorned in an appliqué
technique with hand-modeled
flowers.

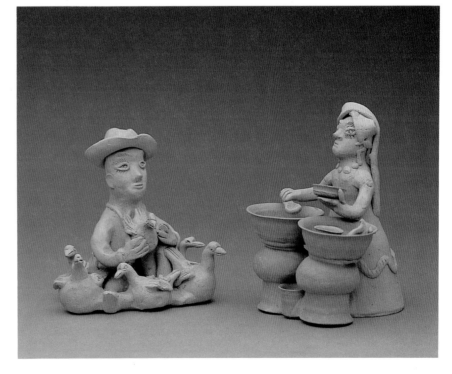

10.
Vendors
Teodora Blanco
Atzompa, Oaxaca
Clay: hand-modeled, appliquéd, incised,
single-fired, (used as crèche figures)
20 × 15.2 × 12.5 (avg.)
1985/1.242 A, C

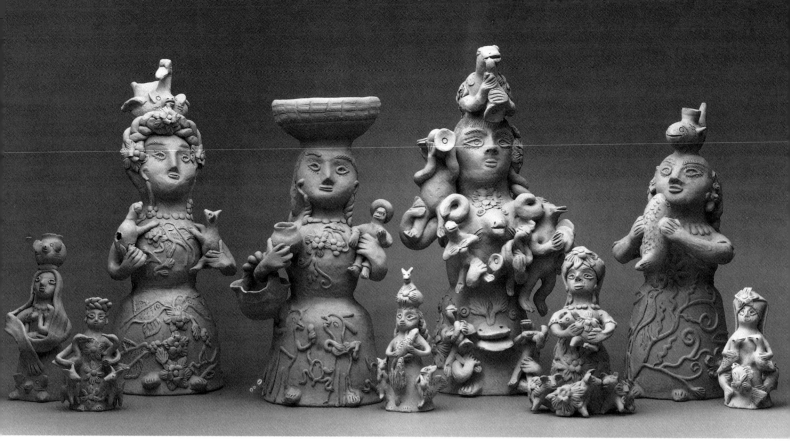

11.
Dolls
Teodora Blanco
Atzompa, Oaxaca
Clay: hand-modeled, appliquéd, incised,
single-fired
11.4 × 11.4 to 61 × 31
Left to right:
1985/1.242 D, .234 B, .230 A,
.297 A, .234 C, .230 C, .242 B,
.297 B, .234 A

12.
Doll
Teodora Blanco
Atzompa, Oaxaca
Clay: hand-modeled, appliquéd, incised, sin-
gle-fired
86.5 × 28 × 30.5
1985/1.228

This decorative figure probably repre-
sents a market vendor wearing the
characteristic headdress of Oaxacan
women, a woolen yarn braid that
encircles the head. Balanced on it is a
duck-shaped vessel, and in her arms
are two animals. Her body is covered
with appliquéd, hand-
modeled flowers and birds reminis-
cent of old, richly embroidered Indian
huipiles (pre-Hispanic-style blouses).
This piece is representative of the last
works of Teodora Blanco, who dedi-
cated herself to making dolls of differ-
ent sizes. Prior to this, she produced
small animals called *palilleros* (tooth-
pick holders), which are characteristic
of Atzompa.

The style of this figure exemplifies
the purest traditional indigenous
ceramics of Mexico, and shows how
potters gradually change utilitarian
forms into decorative pieces.

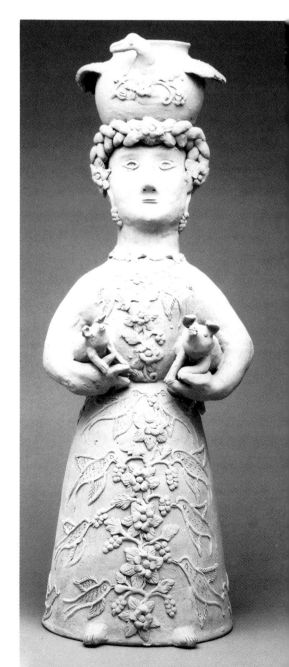

The Fantasy of the Artisan

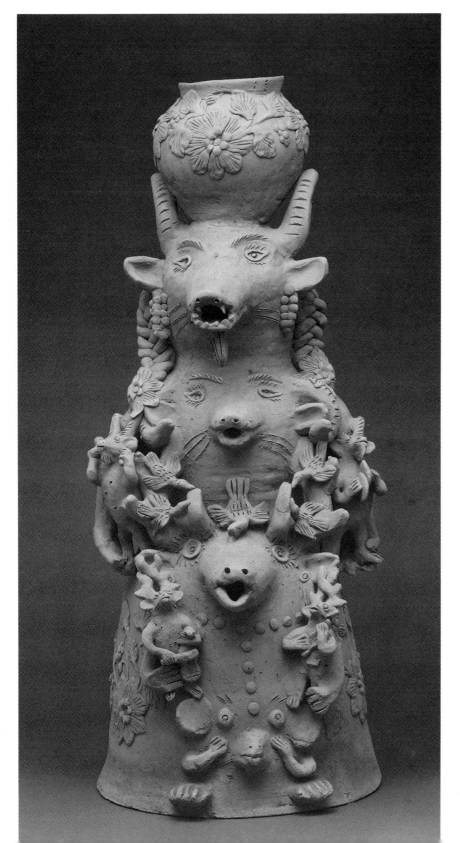

Folk art reflects, above all, the manual dexterity of its producers. Mexico's artisans have always utilized materials readily available to them, but the last few years have seen a very important change: they now manufacture an increasing number of decorative rather than utilitarian objects. Decorative pieces manifest the fertile imagination of the artisans, especially ceramists who create works of great merit. They are inspired by traditional pieces, religious themes, or new themes suggested by others or chosen by the artisans themselves. The folk art thus created clearly embodies each artist's fantasy.

13.
Doll
Teodora Blanco
Atzompa, Oaxaca
Clay: hand-modeled, incised, appliquéd, single-fired
89 × 38.2 × 33
1985/1.229

This fantastical doll is composed of four animals, one on top of another, united as one body. It shows four faces: three of animals that look like rabbits; and one more, the principal face, which belongs to an animal with horns (probably a cow). Though this figure is zoomorphic, it has a thick, humanlike braid on each side of its head, giving more volume and balance to the upper part of its body.

Each animal has arms and hands, and the middle two carry other, smaller figures. A pot supported by the uppermost head, between its horns, is adorned with appliquéd flowers. The figure's feet do not touch the ground; they are attached to the skirt.

Among this object's traditional elements are little clay animals similar to those used in Atzompa as toothpick holders.

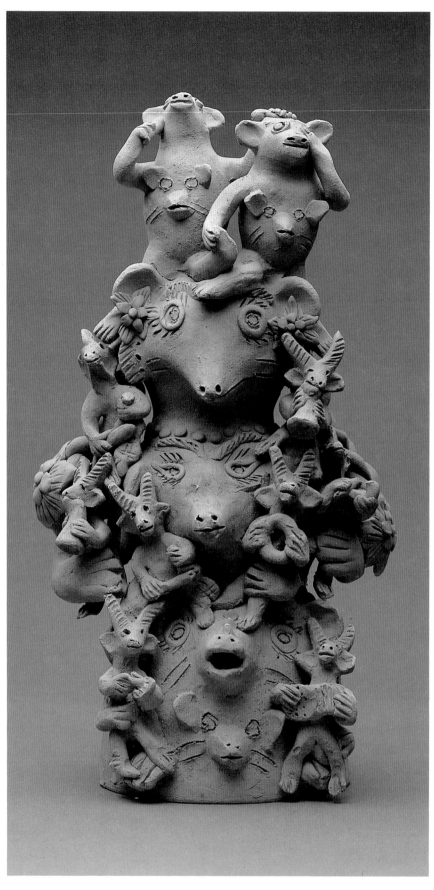

14.
Doll
Teodora Blanco
Atzompa, Oaxaca
Clay: hand-modeled, incised, appliquéd,
single-fired
41 × 15
1985/1.230 A

This figure's ten small animals complement the previous figure with four faces. Truly a fantasy sculpture, it reflects the artistic sensibility, fertile imagination, and extraordinary manual dexterity of its creator.

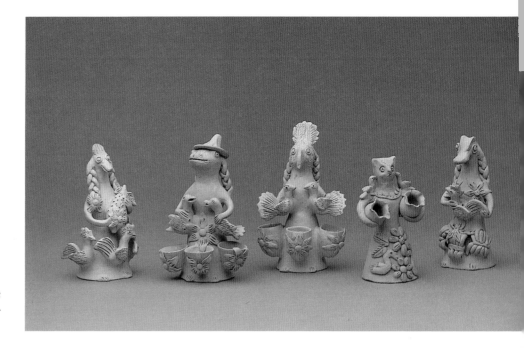

15.
Animals
Teodora Blanco
Atzompa, Oaxaca
Clay: hand-modeled, appliquéd, single-fired
17.5 × 10 × 7.5 (avg.)
1985/1.233 A–E

Though all zoomorphic, each of these pieces has Blanco's trademark human-like braids.

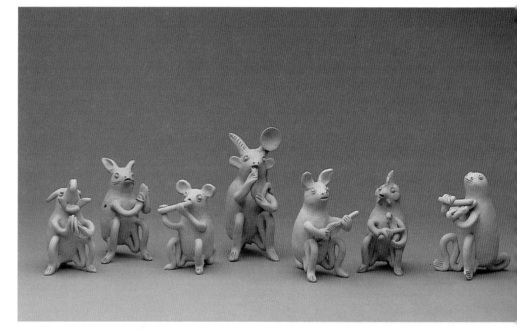

16.
Musicians
Atzompa, Oaxaca
Clay: hand-modeled, single-fired
17.5 × 20 (avg.)
1985/1.237 A–I

These traditional zoomorphic figures influenced later pieces created by Teodora Blanco and other artisans in her family. Three holes on their necks prevent the pieces from exploding when they are fired and also make them functional as *palilleros* (toothpick holders). Originally, such items were much smaller and were finished with green glaze.

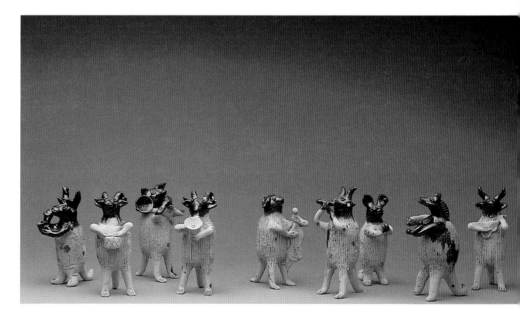

17.
Band of musicians
Atzompa, Oaxaca
Clay: hand-modeled, single-fired, *chía* seed planter
12.5 × 15.2 (avg.)
1985/1.238 A–I

The vertically striated surface on these figures holds *chía* seeds (from lime-leaved sage) against the clay. When the container is filled with water, moisture seeps through the surface of the porous, unglazed clay, and dense vegetation crops up to cover the figure with a short, green mantle.

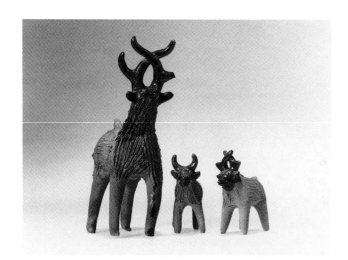

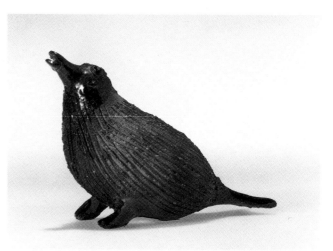

18.
Deer
Atzompa, Oaxaca
Clay: hand-modeled, partially glazed in green,
chía seed planter
Left to right:
25 × 12.5 1985/1.47
10 × 10 × 5 (avg.) 1985/1.298 A–B

19.
Chía animal
Atzompa, Oaxaca
Clay: hand-modeled, partially glazed in green,
chía seed planter
15.2 × 10 × 8.5
1985/1.48

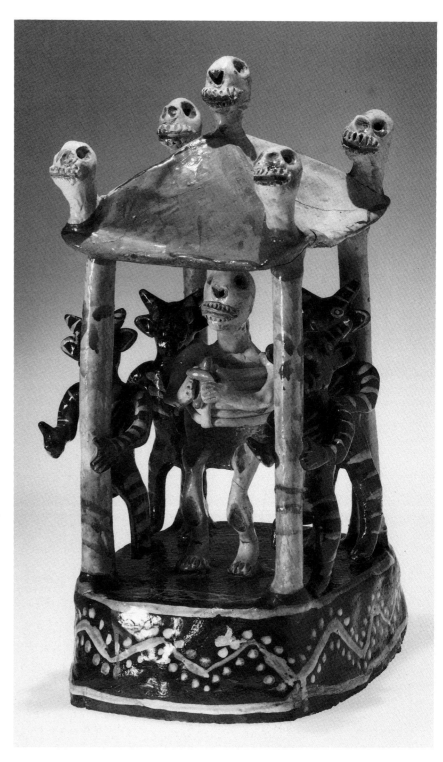

20.
Skeleton with devils
Ocumicho, Michoacán
Clay: hand-modeled, single-fired, painted
with anilines dissolved in water, varnished
38.2 × 21.5 × 22.5
1985/1.244

These pieces are part of the present-
day production of Ocumicho, the
indigenous clay production center of
Michoacán that transformed its tradi-
tional toys into fantasy and religious
figures.

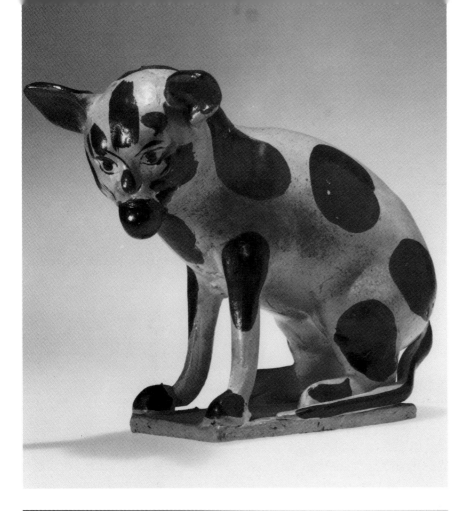

Toys

Toys, the most consistent examples of folk art in Mexico, preserve traditional characteristics of form, size, color, and materials. The following plates illustrate some of the most beautiful toys in the Rockefeller collection.

21.
Cat
Julián Acero
Santa Cruz de las Huertas, Jalisco
Clay: formed on an old mold, single-fired, painted with aniline dyes, varnished
20 × 17.5 × 10
1985/1.163

This cat bank comes from the pottery center near Tonalá whose traditional ceramic production consisted of masonry tubes, toilets, and rainspouts. Several artisans there, in Santa Cruz de las Huertas, also produced clay toys like this one as well as figures of tumblers and tightrope walkers with ingenious mechanisms that allow them to move. At present, toy production is declining; little by little, it gives way to new pieces such as those of Candelario Medrano and his family.

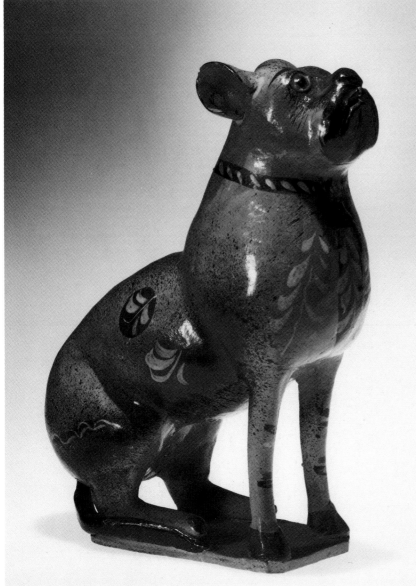

22.
Dog
Julián Acero
Santa Cruz de las Huertas, Jalisco
Clay: formed on two old-style molds, single-fired, brush-painted with aniline dyes, varnished
24.5 × 9 × 15.5
1985/1.277 D

The motifs on this dog bank are commonly used in traditional folk pottery. The splotches are created by blowing darker dyes from a brush onto the painted surface. This particular figure was made from two separate old-style molds; unfortunately, the mold of the head has disappeared.

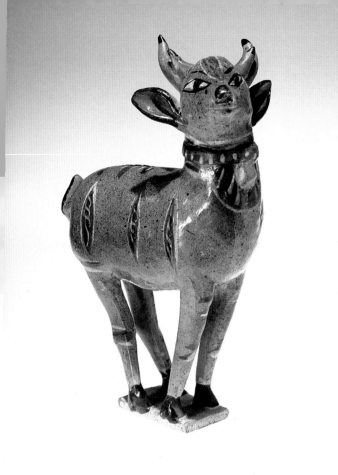

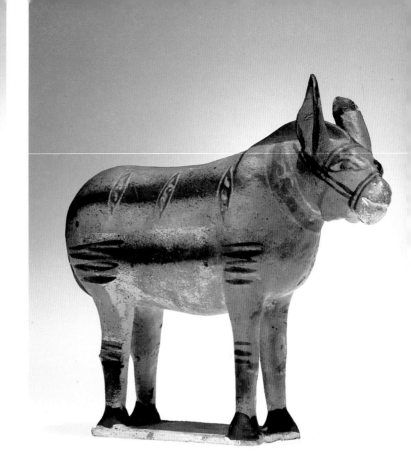

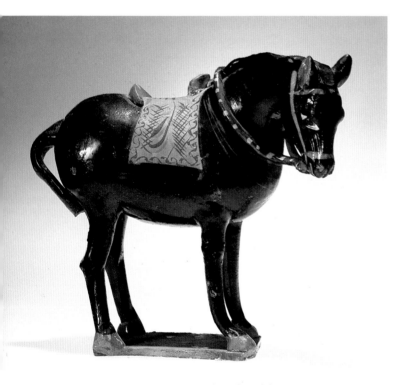

Banks in Mexico are produced in different sizes called *dieciochitos* (little eighteens), *veinticuatros* (twenty-fours), and *treinta y seises* (thirty-sixes)—their cost per dozen in pennies at the beginning of this century. Though many of the old molds have been lost, the few pieces still being made retain these names. This is a group of "thirty-sixes."

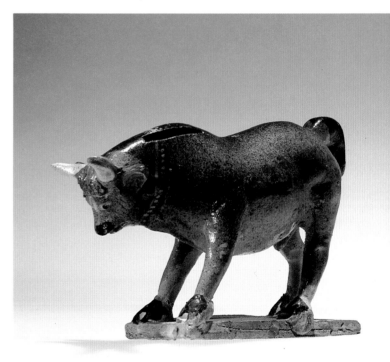

23–26.
Deer, donkey, horse, bull
Santa Cruz de las Huertas, Jalisco
Clay: hand- and moldmade, single-fired, painted with aniline dyes and one coat of varnish
Plate 23:
33 × 22.5 × 12.5 1985/1.277 C
Plate 24:
22.5 × 20 × 19.2 1985/1.217
Plate 25:
33 × 22.5 × 12.5 1985/1.277 B
Plate 26:
15.2 × 10 × 19.5 1985/1.218

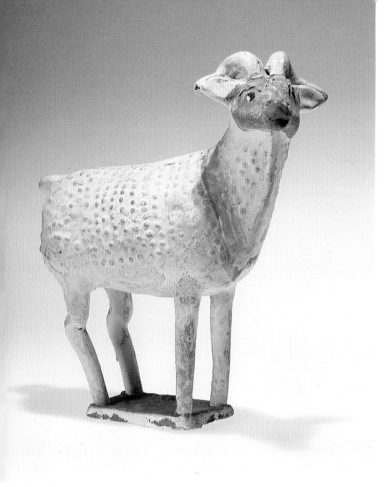

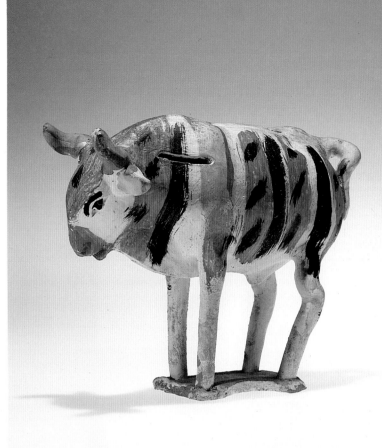

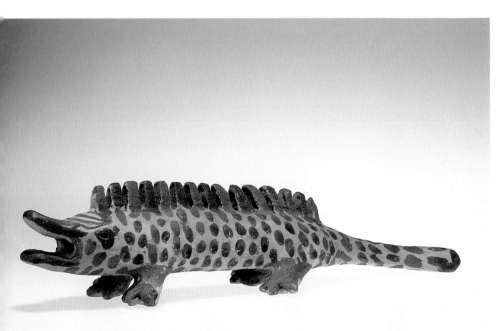

27–28.
Ram, bull
Metepec, state of Mexico
Clay: shaped on old-style molds, single-fired,
with one coat of white calcium carbonate and
traces of color on the head and body
Plate 27:
33 × 21 × 10.5 1985/1.278 C
Plate 28:
25.5 × 22.5 × 12.5 1985/1.278 A

The colors in these banks typify the
original decoration of this type of
ceramic. The ram and bull are valu-
able examples of traditional folk toys
of this area that are no longer
produced.

29.
Crocodile
Amatenango del Valle, Chiapas
Clay: hand-modeled, single-fired, brush-
painted with slips prepared by the artisan
10.5 × 37.5 × 7.5
1985/1.189 B

30.
Head
Tonalá, Jalisco
Clay: formed on traditional mold, single-
fired, brush-painted with aniline dyes
17.5 × 14 × 15.2
1985/1.100 B

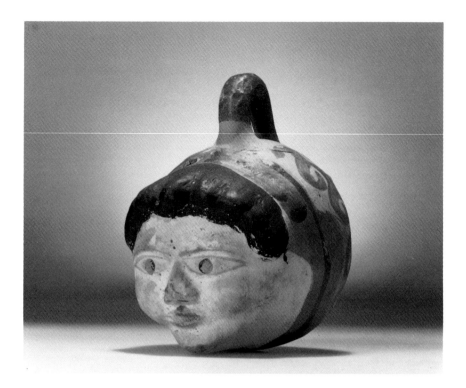

This form is well established in
Mexico's history: it also appears as a
decorative motif in seventeenth-
century Tonaltecan vessels and pots.
At some point, artisans began using
the mold as a bank, a custom that per-
sists to this day.

Traditionally, pieces such as this
head are decorated with floral motifs
painted with slips and burnished. In
this case, the artisan chose to change
the decoration to a scroll design.

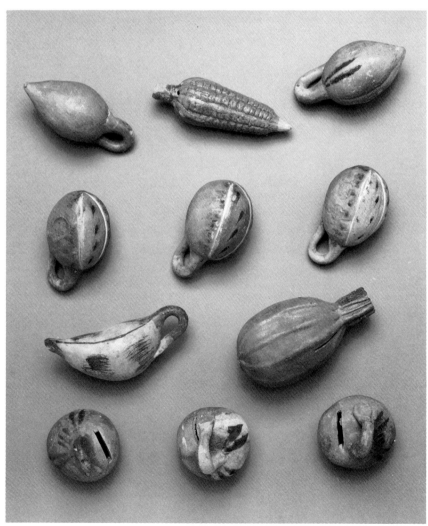

31.
Fruit
Tonalá, Jalisco
Clay: formed on old-style molds, single-fired,
brush-painted with aniline dyes
18 (avg. circum.)
1985/1.185 A–K

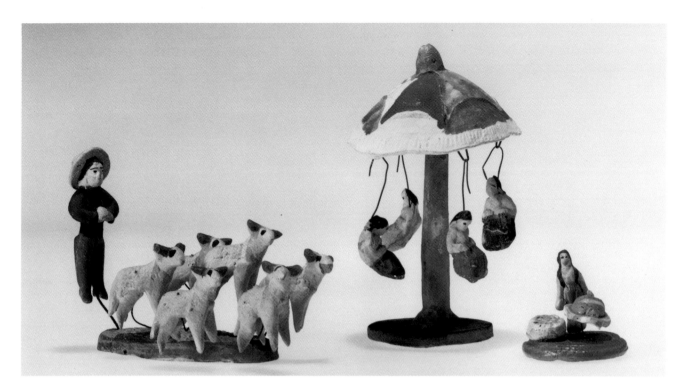

32.
Shepherd, merry-go-round, and vendor
San Pedro Tlaquepaque and Santa Cruz de
 las Huertas, Jalisco
Clay: hand- and moldmade, single-fired,
brush-painted with aniline dyes
Left to right:
11.4 × 7.5 1985/1.177
12.5 × 7.5 1985/1.178 A–B
5 × 3.6 1985/1.183

The vendor is made from an old-style mold from Tlaquepaque. A popular toy from Santa Cruz de las Huertas, the merry-go-round is moldmade except for its post. The shepherd and sheep are a crèche grouping from San Pedro Tlaquepaque. All are traditional toys.

33.
Bird, young girl, and snake
Ocumicho, Michoacán, and San Pedro
 Tlaquepaque
Clay: hand- and moldmade, single-fired,
brush-painted with aniline dyes dissolved in
water
Left to right:
6.5 × 5 1985/1.357
12.5 × 6.5 1985/1.160
6.5 × 7.5 1985/1.184 A

The traditional moldmade little doll is an example of the toys of Ocumicho that are disappearing to a certain degree. The bird is a whistle, also from Ocumicho. The snake comes from San Pedro Tlaquepaque and is one of the wire toys of that region that have now vanished altogether.

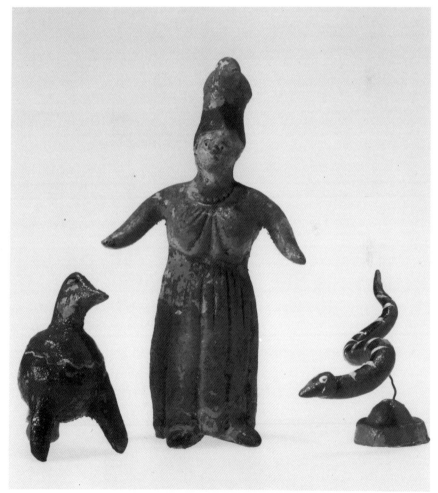

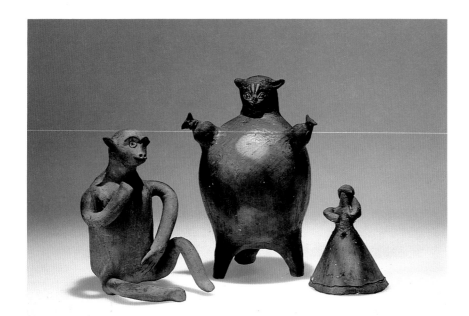

34.
Monkey, owl, and girl
San Bartolo Coyotepec, Oaxaca
Clay: hand-modeled, single-fired
Left to right:
17.5 × 12.5 1985/1.138
21 × 12.5 1985/1.139
11.4 × 8.8 1985/1.176

The clay in these figures is not burnished, resulting in a grey and opaque tone uncharacteristic of this type of ware. Openings in the two large pieces convert them into whistles. The girl functions as a bell.

35.
Wise men
Soteno family
Metepec, state of Mexico
Clay: formed on modern molds, single-fired, brush-painted with aniline dyes
63.5 × 33 × 30.5 (avg.)
1985/1.247 A–C

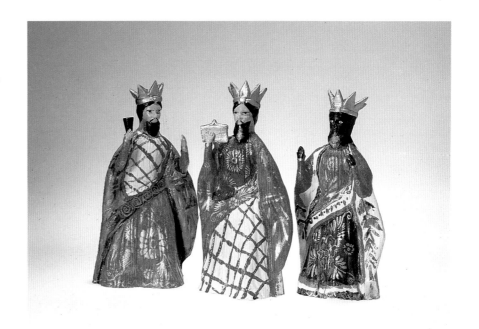

36.
Box
Paracho, Michoacán
Shake wood: brush-painted with aniline dyes mixed with watered glue
10.2 × 15.2 × 10
1985/1.20 A

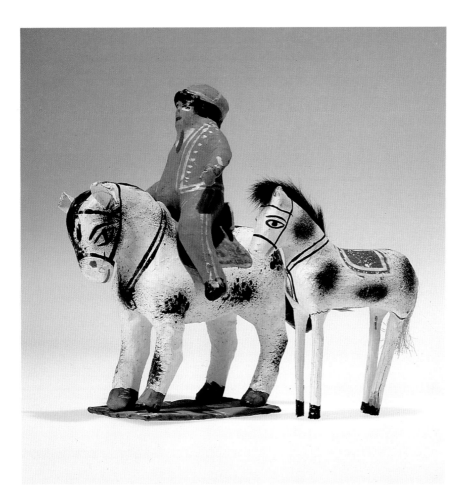

37.
Horses
Celaya, Guanajuato
Papier-mâché: formed on old and modern
molds, painted with aniline dyes
Left to right:
24 × 24 × 8.8 1985/1.327
16 × 13.3 1985/1.179

38.
Caimán masks
Celaya, Guanajuato
Papier-mâché: formed on old-style molds,
decorated with aniline dyes mixed with water
and glue, varnished
24 × 20 × 17.5
1985/1.41 A–B

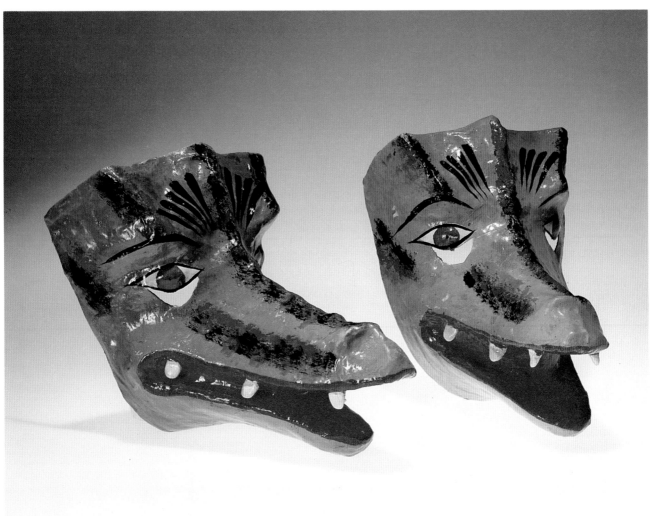

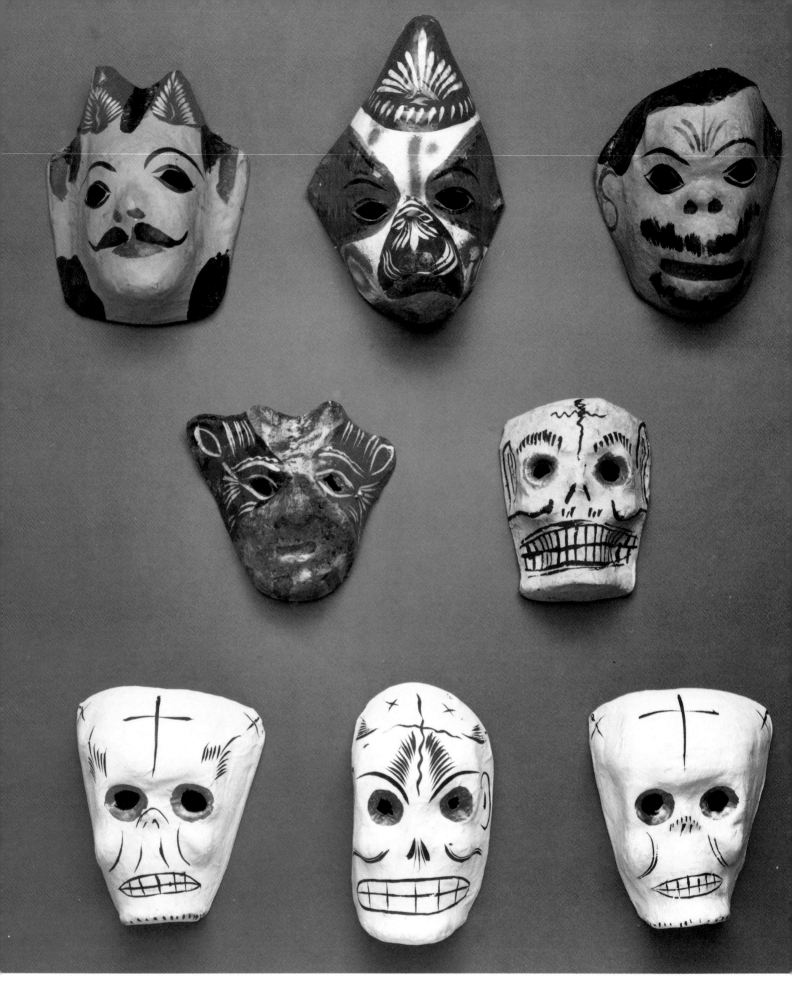

39.
Masks
Celaya, Guanajuato
Papier-mâché: formed on old-style molds,
brush-painted using aniline dyes mixed with
watered glue, fully or partially varnished
20 × 17.5 × 9 (avg.)
1985/1.29 A–H

The features on these masks are not
well defined because artisans without
molds make copies directly from
other masks. Each time a mold is
made this way, it loses fidelity.

These traditional toys are used dur-
ing the Lenten season.

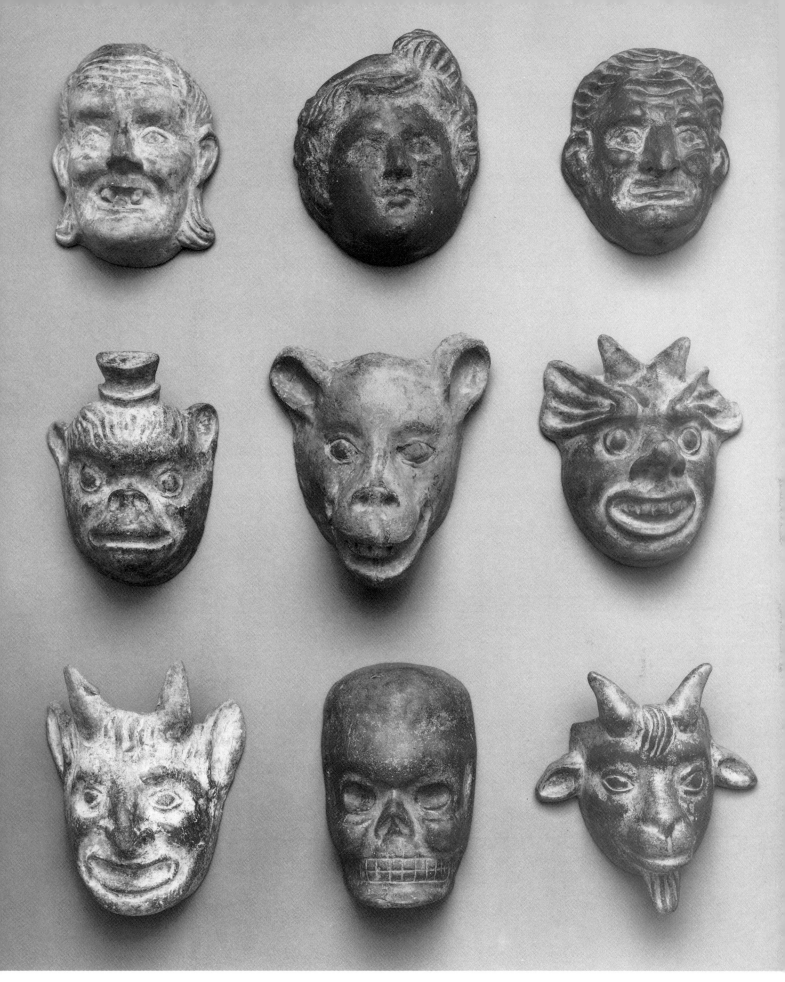

40.
Molds
Celaya, Guanajuato
Clay: single-fired
15.2 × 12.5 (avg.)
1985/1.19 A–I

These antique molds are used to produce papier-mâché masks for children. All are authentic molds of traditional form.

Ritual Objects

Folk art of a ritual or religious nature has vanished little by little as various practices decline, and objects that were once utilitarian have become purely decorative. Such is the case with many of the old masks originally used for fiestas and folk dances; many exist now only in private collections.

Still in use, however, are religious objects such as the classic *copal* (incense) burners and candelabra. Some of these pieces have inspired the manufacture of large-scale candelabra for ornamental use.

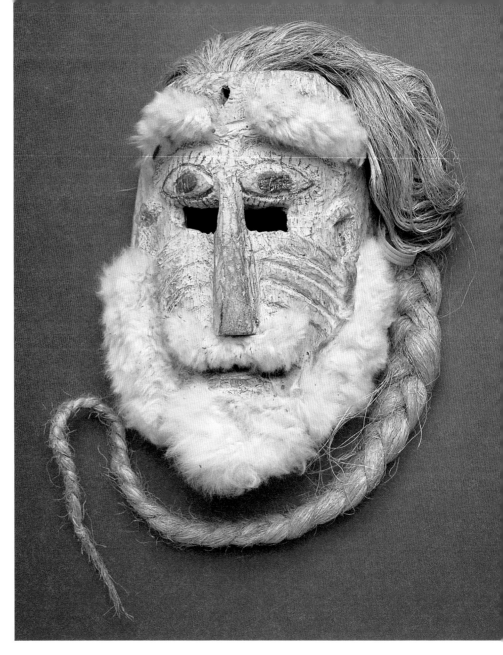

41.
Mask
Provenance uncertain
Wood: carved, painted with tempera and (for the red lines of the face and eyes) pencil. Eyebrows, beard, and moustache are of rabbit fur; wig is of *ixtle* fiber (from the maguey plant).
35.5 × 20
1985/1.64

42.
Masks
Guerrero and Michoacán
Wood: carved, painted
Left to right:
15.2 × 17.5 1985/1.265
15.2 × 14 1985/1.197
19 × 14 1985/1.266

The mask with a mottled painted surface was given a base coat of white, a second coat of black, and then scraped. It probably corresponds to the Danza de los Negritos (Dance of the Negroes). Strips of pigskin serve as eyebrows.

The mask with the moustache was painted in oils and probably also comes from Michoacán. The pink mask is new, and carved of *tzompantle* (cottonwood), painted with oils, and aged with ash and oil.

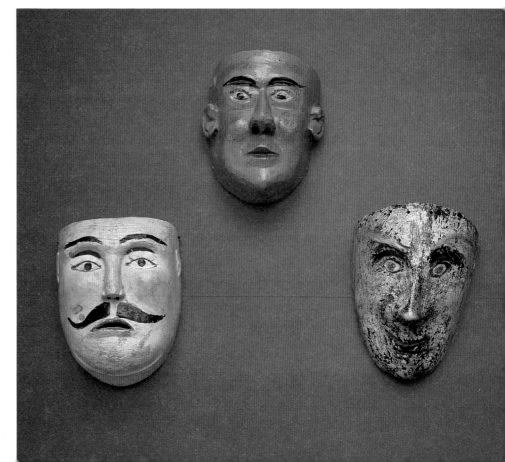

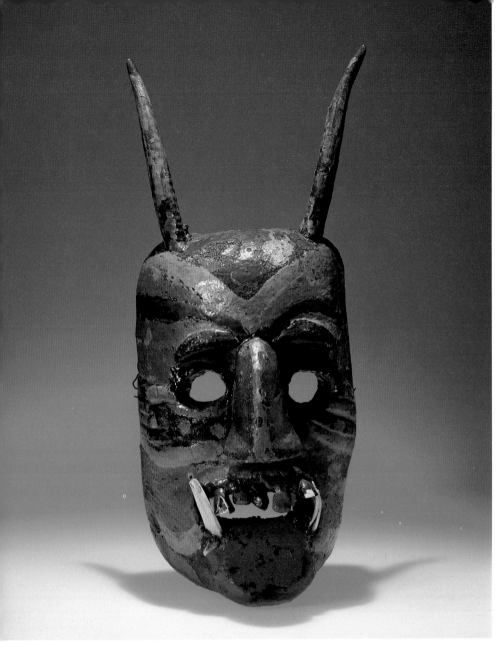

43.
Devil mask
Provenance uncertain
Wood: hand-carved, painted with oils
43.5 × 16.5 × 16.5
1985/1.136

The devil image is a traditional mask form popular in various states for folk dances.

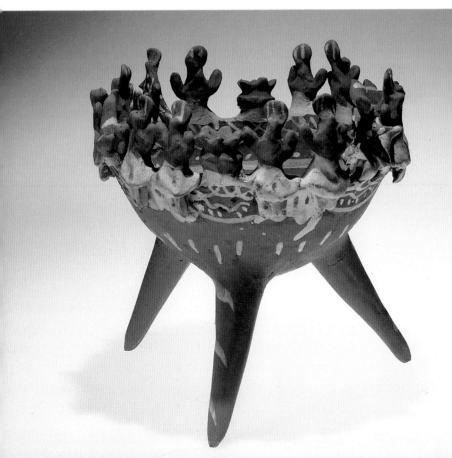

44.
Incense burner
Ocotlán de Morelos, Oaxaca
Clay: hand-modeled, single-fired, brush-painted with aniline dyes on a background of white tempera
22.5 × 22.5
1985/1.54

Anthropomorphic figures on the border of this vessel represent departed souls for whom an offering of *copal* (a type of incense) is made during religious ceremonies or during the Day of the Dead, an annual festival held November 2.

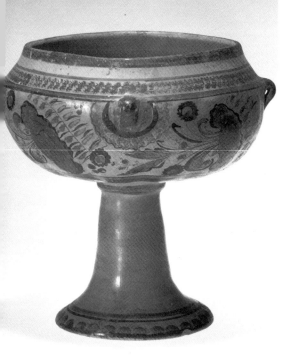

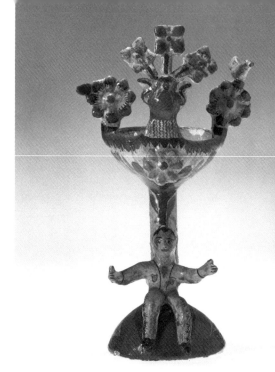

45.
Copal burner
Tonalá, Jalisco
Clay: single-fired, brush-painted, burnished
21 × 19
1985/1.107

The thin walls of this receptacle for burning incense, especially *copal*, are painted with a refined floral design. Its style and colors are traditional, but its form is in disuse in its place of origin.

46.
Copal burner
Izúcar de Matamoros, Puebla
Clay: hand- and moldmade, single-fired, brush-painted with aniline dyes dissolved in water (over a white background of engobe), varnished
25 × 7.2
1985/1.320

47.
Candelabra
Izúcar de Matamoros, Puebla
Clay: partially formed on a mold, single-fired, brush-painted with a mixture of tempera and aniline dyes dissolved in water (over a coat of white zinc oxide and white calcium carbonate), varnished with a solution prepared by the artisan from the resin of the *oyamel* tree and *nopal* (prickly-pear cactus) juice
48 × 44 × 7
1985/1.271

Though this candelabra is decorated with virgins and angels, no Spanish antecedents exist for this type of object. Some experts suppose its style originated in Huaquechula, Puebla, and that potters there emigrated to Izúcar de Matamoros in the same state, transplanting production. Izúcar is a more likely origin; the Huaquechulan style is simpler in form and coloring and its pieces are more often used for crèches. In any case, Izúcar, Huaquechula, and Metepec form a triangle and produce polychromed aniline ceramics of a religious and ceremonial nature.

The candelabra from Izúcar best represents traditional decoration, size, and coloring; it has not been affected by the large demand for this type of object. However, it is an endangered folk art since only the Flores family produces it in its original style. Aurelio Flores, the head of the family, no longer works. Only his son, Francisco, continues the tradition.

According to Aurelio Flores, these pieces were originally used to adorn wedding altars and then given to the newlyweds.

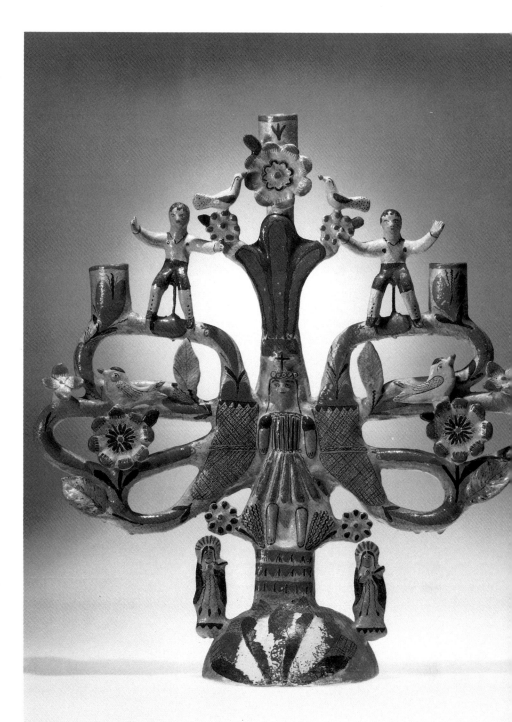

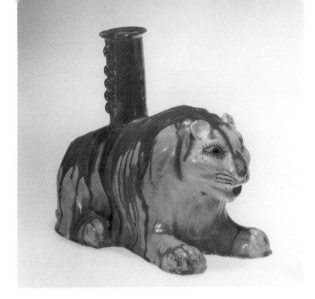

48.
Lion-shaped candle holder
Santa Fe de la Laguna, Michoacán
Clay: formed on a modern mold, dripped
with yellow and green glaze
20 × 11 × 4
1985/1.79 B

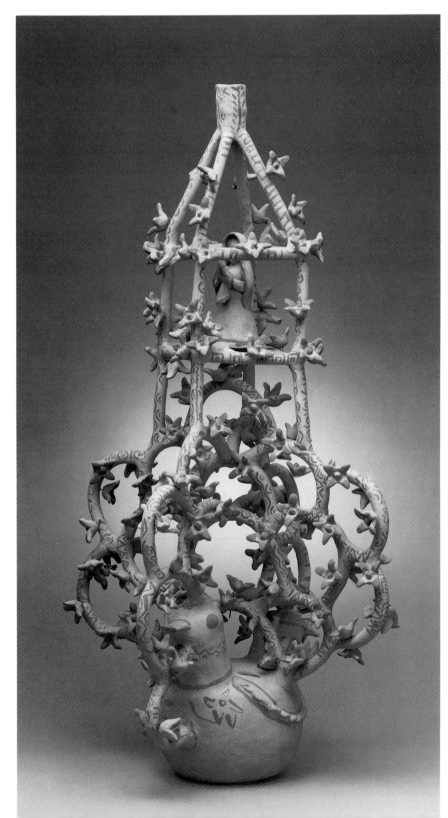

49.
Candelabra
Artisans directed by Herón Martínez
 Mendoza
Acatlán, Puebla
Clay: hand-modeled, single-fired, brush-
painted with slips
86.5 × 38.2
1985/1.293

The base of this decorative can-
delabra, a duck, upholds the entire
structure of hand-formed clay coils
with no internal support. The flowers
and figures are also made by hand.

Shards found in Acatlán demon-
strate that people have produced pot-
tery there since pre-Hispanic times,
and much of today's decoration is
inspired by that of the ancient pieces.
The area's potters originally created a
great variety of utensils for domestic
use: jugs, water vessels, bowls, barrels,
pots, pitchers, toy dishes, and small
candle holders for the festivities of All
Saints' Day. The latter form gave rise
to the larger decorative candelabra
now made. For pieces such as this,
potters developed new techniques to
build and fire large sections without
breakage.

The finish of the pieces has evolved
from natural-colored clay shown here.
Leather tones, burnishing, and a tech-
nique similar to the one used in San
Bartolo Coyotepec, Oaxaca, are also
employed.

Herón Martínez and the artisans of
Acatlán have been so successful that
colleagues in other pottery centers are
copying their wares. But although
new artisans have emerged, particu-
larly among the young people, no one
has yet surpassed Herón's mastery.

41

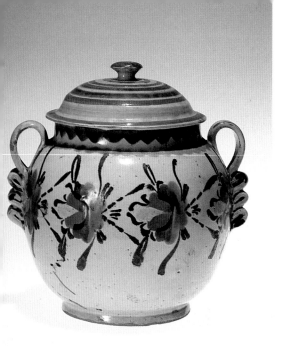

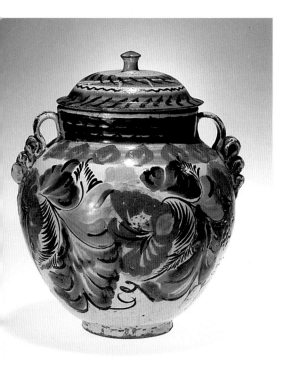

Ceramic Ware

Even before the Spanish Conquest, pottery was a common form of expression for the people of Meso-america. This tradition began with primitive, simple vessels and evolved into beautiful and unequaled pieces, in which the manual dexterity and artistic conception of these indigenous peoples came together in authentic manifestations of art.

Pottery's tradition weathered the cataclysm of the conquest. Even though some indigenous forms and decorations perished during the three centuries of Spanish dominion, other traces of that heritage are still reflected in many pieces made today. For example, in objects with appliquéd decoration and certain vessels and water jugs, ancestral forms remain intact.

In this section, which illustrates glazed and unglazed ceramic objects, one can appreciate the richness of forms and decoration in Mexico's present-day pottery. In many cases, this richness results from *mestizaje*, the fusion of Hispanic culture with the indigenous one.

The forms of these vessels are characteristic of antique majolica. Their shape, refined decoration, and brilliant colors constitute good examples of traditional ware produced in Guanajuato--particularly the oldest piece, which displays the most profuse floral decoration.

The technique, form, and decoration of this ware date to the latter part of the eighteenth century and came to Mexico from Spain. The first pottery workshops established to produce majolica were located in Puebla. Subsequent workshops followed in Oaxaca, Guanajuato, Dolores Hidalgo, Sayula, and other places, each of which adopted and maintained distinctive characteristics of decoration. In most of these places today, majolica has either vanished or degenerated, but Guanajuato retains the antique style and technique of production and Puebla preserves its white ware.

Toward the end of the nineteenth century, majolica was threatened with extinction when the pottery workshops began to close in the Barrio de San Luisito, Guanajuato. Fortunately, production eventually resumed using the old forms, techniques, and decorations. Today's ware exhibits an abundance of brilliant blues, contrary to previous times when colors were prepared with tin oxide and local mineral colorants that produced coral, red, brown, yellow, and green.

Traditional decoration is distinguished by a floral polychromed composition or by arrangements of blotches of strong monochromatic coloring applied with loose brush strokes (see the green piece, plate 52). Decoration is generally applied by brush, and on a smaller scale, the traditional graffito (scratch) technique is used. Guanajuato is known for lidded pots, tall vases, washbasins, chamber pots, pitchers, plates, and platters.

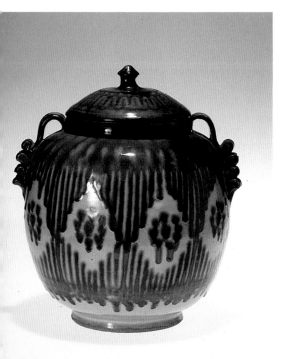

50–52.
Jars with lids
Guanajuato, Guanajuato
Clay: wheel-thrown, brush-painted, enamel finish
Plate 50:
25 × 22.5 1985/1.81 A–B
Plate 51:
25 × 22.5 1985/1.267 A–B
Plate 52:
24 × 19 1985/1.82 B–C

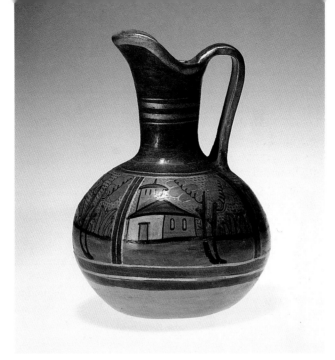

53.
Pitcher
Tonalá, Jalisco
Aromatic clay: formed on an old-style mold,
single-fired, brush-painted with tempera
25 × 17.5
1985/1.263

Tonalá clay characteristically gives an
aroma and flavor to the liquid stored
in the finished pottery and is therefore
called *loza de olor* (aromatic pottery).

This pitcher's decoration, on the
other hand, is not in keeping with the
folk art tradition of Tonalá. Its use of
purple, green, and red is foreign to
burnished ceramics, to which this
piece seems to correspond. Ton-
altecan ware is typically decorated
with dots and bands of gold and silver
(see plate 55).

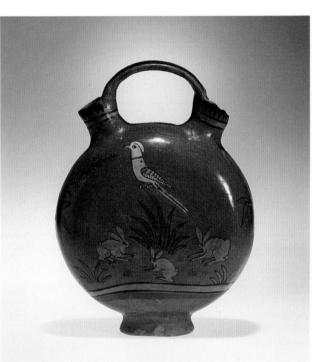

54.
Flask
Tonalá, Jalisco
Aromatic clay: formed on an old-style mold,
single-fired, brush-painted, varnished
24 × 17.5 × 7.5
1985/1.299

This piece has elements that are unor-
thodox in this type of ware, such as
the blue bands. The background is
also new; the traditional color scheme
is more somber, using shaded white
and grey tones with black lines.

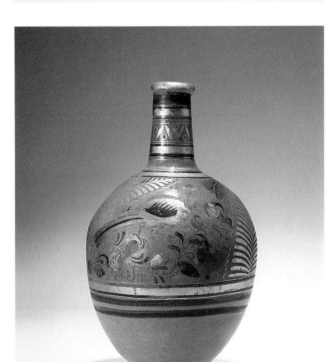

55.
Water bottle
Tonalá, Jalisco
Aromatic clay: formed on an old-style mold,
single-fired, brush-painted in silver and gold
32 × 17.5
1985/1.50

This thin-walled vessel's beautiful
floral design establishes its artisan's
mastery. Such use of gold and silver
has now been completely abandoned
in Tonaltecan pieces. Though this
piece has a burnished surface, other
elements, such as the pink and green
colors, are foreign to this type of
ware.

Customarily, a water bottle such as
this is accompanied by a drinking cup
placed over its neck.

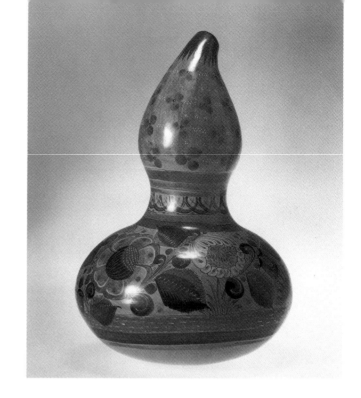

56.
Bule (gourd)
Tonalá, Jalisco
Clay: formed on a contemporary mold of
antique design, single-fired, brush-painted,
burnished
35.5 × 24
1985/1.290

The upper part of this water vessel
shows the classic decoration called *de
percal*, an overall design of little
flowers or scrolls. The lower part dis-
plays floral decorations characteristic
of Tonaltecan pottery's traditional
style.

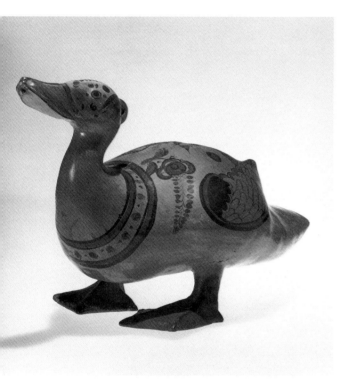

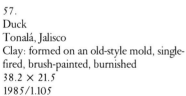

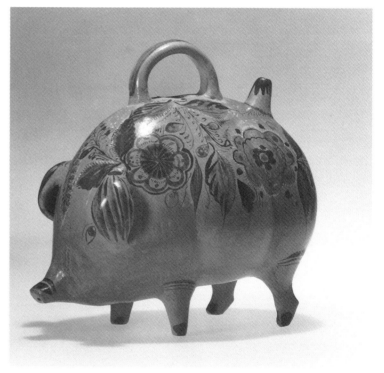

57.
Duck
Tonalá, Jalisco
Clay: formed on an old-style mold, single-
fired, brush-painted, burnished
38.2 × 21.5
1985/1.105

The small handle on the back of this
duck's head is more for adornment
than to support this thin-walled vessel.
In the body's upper part is an opening
to receive water. At one time, Ton-
altecan ware was preferred for water
storage because its aromatic clay
imparts a fresh flavor to liquid kept in
it. Such ducks are still made, but they
are now deemed ornamental since
people no longer use them to hold
water.

58.
Pig
Tonalá, Jalisco
Clay: formed on an old-style mold, brush-
painted, burnished
22.5 × 22.5
1985/1.101

This mold is generally used for money
banks, but the artisan in this instance
created a small vessel for a child's use.
The pig's upper part has a handle,
below which are a decorated spout
and an opening to receive liquid.

These vessels are no longer made,
because they have no function. Piggy
banks with burnished decoration are
also rare.

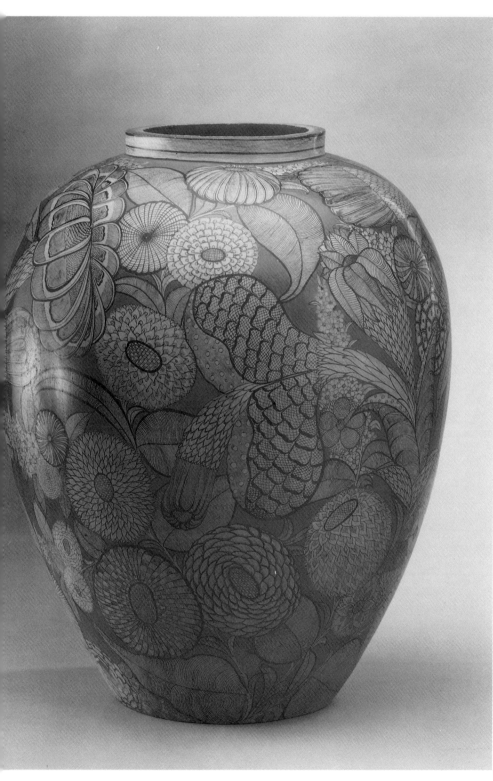

This decorative vessel's coloring and decoration differ from the traditional, particularly the blue background. The floral design covering the entire surface results from the so-called horror vacui, believed by some to be the reason Mexican artisans decorate their pieces so lavishly.

Tonalá is one of Mexico's principal pottery centers and produces glazed pottery, slip-painted pottery, *loza de olor* (aromatic pottery), *bandera* (flag ware), and *petatillo*, which refers to its cross-hatch background design resembling the woven straw mat called *petate*. Techniques and forms vary with each type, but Tonaltecan decoration maintains certain common stylized animals and floral motifs.

Tonalá's most important ware, because of its technique and the beauty of its decoration, is the burnished aromatic clay form, which has been produced for three and a half centuries. Exquisitely decorated jars exist from the seventeenth century, a period characterized by a desire for maximum plastic expression.

During the 1920s, Dr. Atl, an important Mexican artist and political figure, found great activity in Tonalá in the production of burnished aromatic pottery. Production then declined until the 1950s, when a brief renaissance occurred. Today's Tonaltecan pottery shows an unfortunate experimentation with raw materials, shapes, designs, and new colors of poor quality and dubious taste. Exotic models are copied that do not correspond to the ware's folk art tradition, and elements of foreign decoration abound. Like many other Mexican folk art forms, this pottery is not immune to the danger of degeneration and disappearance.

59.
Jar
Tonalá, Jalisco
Clay: formed on a mold, single-fired, burnished
71 × 50
1985/1.109

60.
Pitcher
Santa Fe de la Laguna, Michoacán
Clay: formed on a mold, single-fired, brush-
painted with oil paints
36.5 × 22.5 × 12.5
1985/1.78

This pitcher's shape is an uncommon
utilitarian one. On each side of its
neck is an image of the Mexican flag.
At the rim and base of the neck are
gold-painted decorations. The floral
motifs on this thin-walled water vessel
resemble those of trays produced in
Michoacán.

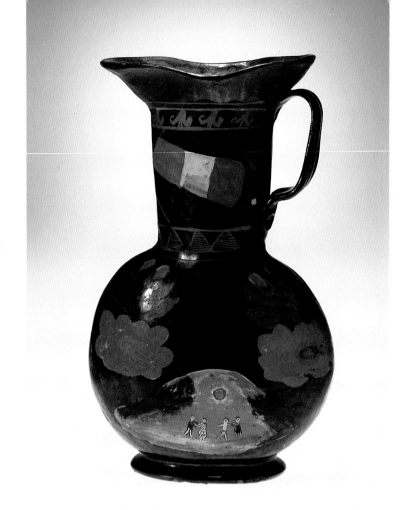

61.
Pitcher
Santa Fe de la Laguna, Michoacán
Clay: formed on a contemporary mold,
glazed
19.5 × 14
1985/1.72

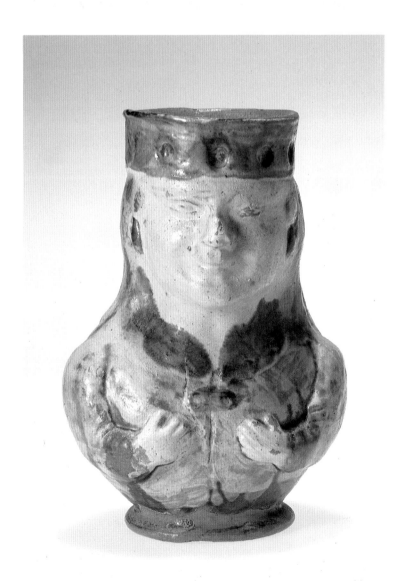

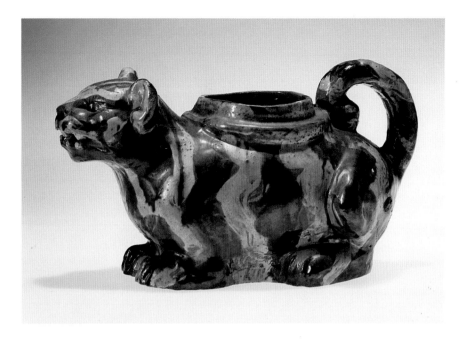

62.
Tiger pitcher
Santa Fe de la Laguna, Michoacán
Clay: formed on a contemporary mold, fired,
dripped decoration, glazed
11.5 × 26
1985/1.79 A

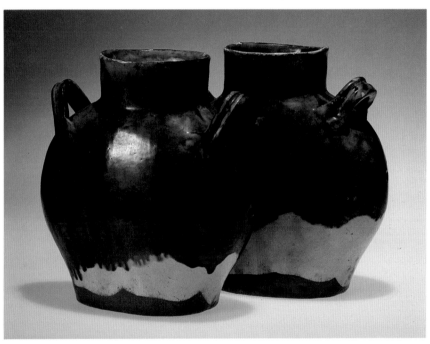

63.
Vases
Santa Fe de la Laguna, Michoacán
Clay: formed on a mold, fired, glazed
19.5 × 18.3
1985/1.137 A–B

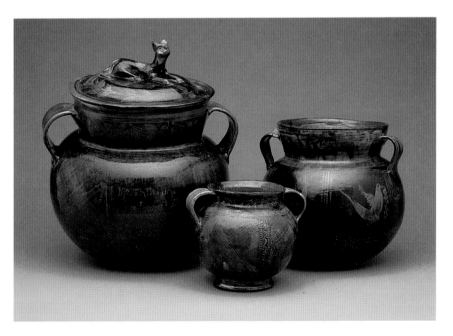

64.
Pots
Patamban, Michoacán
Clay: formed on a mold, fired, brush-painted,
glazed
Left to right:
43 × 19 1985/1.70
19 × 22.5 1985/1.325
28 × 29.3 1985/1.194

Because of their shape, fine decora-
tion, and the extreme thinness of their
walls, these vessels represent Mexico's
finest pottery tradition. The largest
piece, dated 1937, has a lid with a dog
figure modeled by hand, a detail
much in keeping with the taste of the
potters of Patamban. Traditional
forms and decoration—such as the
floral, zoomorphic, and hand-drawn
petatillo motifs illustrated here—are
also well preserved in today's pottery.

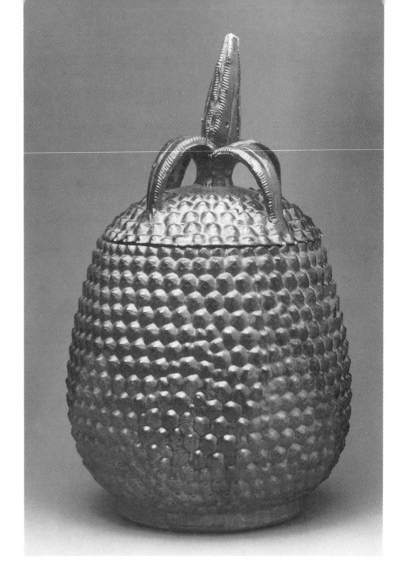

65.
Pineapple jar
San Pedro Tlaquepaque, Jalisco
Clay: formed on a mold, fired, glazed
63.5 × 38.2
1985/1.281 A–B

This vessel is used to store *tepache*, a drink made of pulque, water, pineapple, and cloves.

66.
Water bottle
Provenance uncertain
Clay: wheel-thrown and modeled by hand and mold, appliquéd, fired, glazed
30 × 19
1985/1.53

One of the oldest and most characteristic forms of traditional folk pottery, this type of water vessel is now in disuse. Conventionally, it is accompanied by a drinking cup placed over its neck.

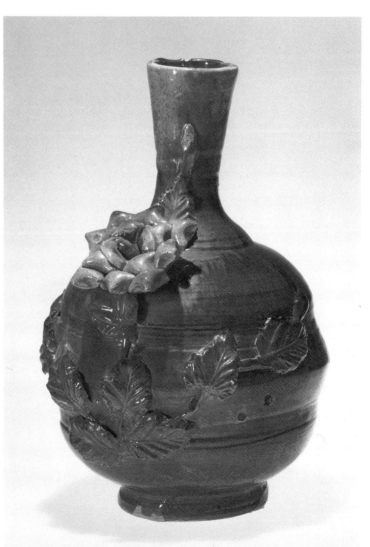

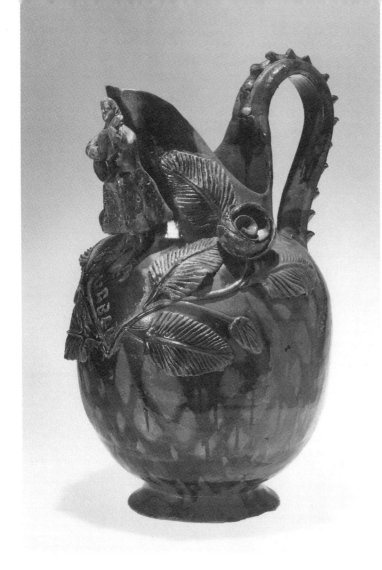

67.
Pitcher
Barrio de la Luz, Puebla, Puebla
Clay: hand- and moldmade, appliquéd, fired,
glazed
48.3 x 34.2
1985/1.141

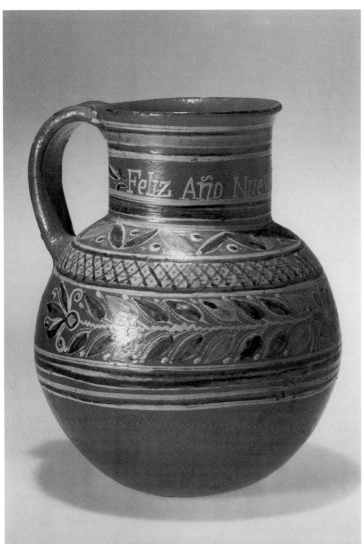

68.
Pitcher
Metepec, state of Mexico
Clay: formed on a mold, fired, brush-painted,
glazed
24 x 19
1985/1.98

On the neck of this vessel, an inscrip-
tion reads "Happy New Year 1940,"
the probable date of its production. Its
traditional floral and geometric motifs
are in blue, yellow, and green.

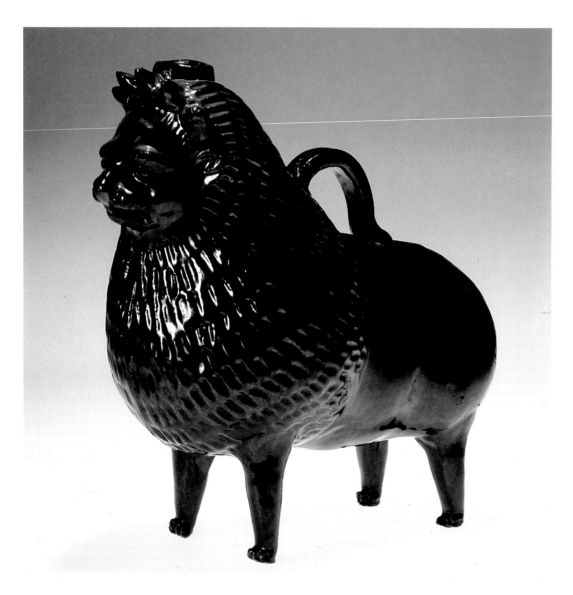

69.
Lion vessel
Metepec, state of Mexico
Clay: formed on an old-style mold, fired,
glazed
22.5 x 22.5 x 12.5
1985/1.61 A

Unlike single-fired ceramics, this
water vessel does not rest on a clay
base. The decoration of the chest and
head gives arrogance and volume to
the figure. Above the head is the
opening, and attached to its back is a
handle. The style of this mold has
almost disappeared.

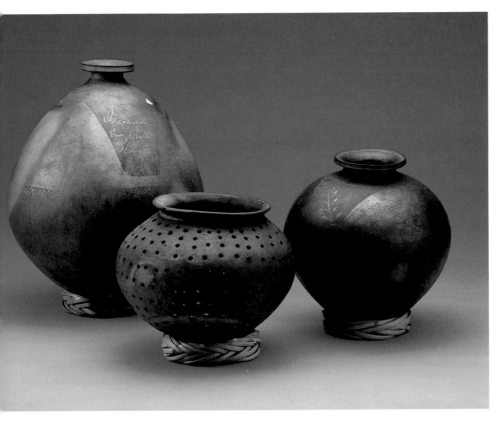

70.
Water jugs and *pichancha* (colander)
San Bartolo Coyotepec, Oaxaca
Black ware: hand-modeled, burnished
Left to right:
42 x 35.5 1985/1.151
25 x 33 1985/1.153
30.5 x 29.3 1985/1.152

This large jug shown here is dated
1940. The *pichancha* is a colander for
straining *nixtamal*, the cooked corn
used to make dough for tortillas.
These vessels are of traditional form
and decoration.

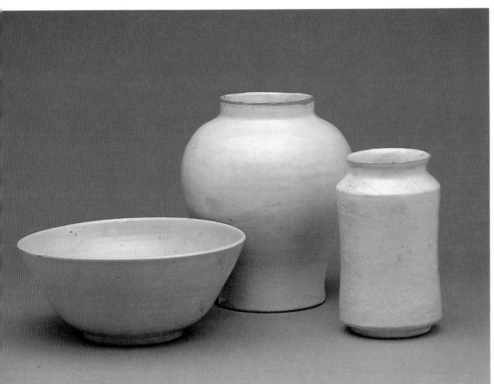

71.
Bowl, vase, and jar
Puebla, Puebla
Clay: majolica white ware, also called *talavera
poblana*, enameled and glazed in traditional
color and form of antique style
Left to right:
16.5 x 7 1985/1.86
26 x 20 1985/1.89
30.5 x 20 x 5 1985/1.87 B

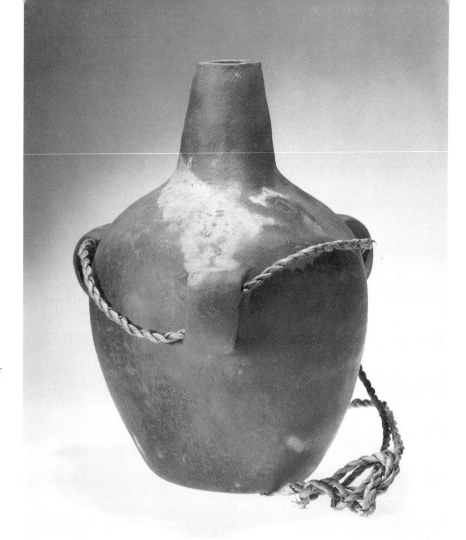

72.
Water jug
State of Mexico
Clay: hand-modeled and formed on a mold of
antique style, single-fired
36 x 26.5
1985/1.198 F

Tied to this water vessel to facilitate
its transport is a cord of woven palm.

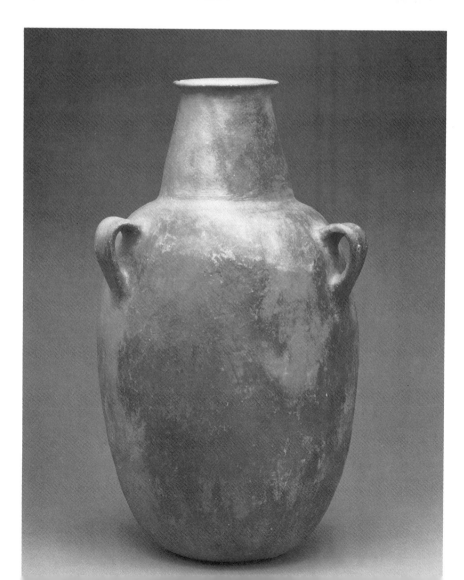

73.
Water jug
Guerrero
Clay: hand- and moldmade in traditional
style, single-fired
46 x 26
1985/1.198 B

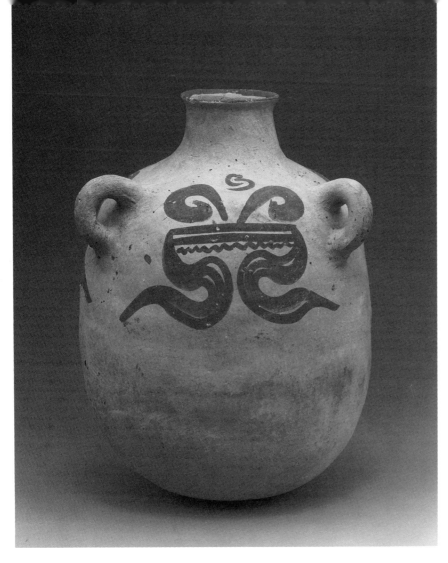

74.
Water jug
Guerrero
Clay: hand-modeled, single-fired,
brush-painted
40 x 29.2
1985/1.198 G

Jugs are the simplest kind of tradi-
tional Mexican pottery. Always sin-
gle-fired and rarely decorated, their
form dates from ancient times and is
preserved today. In some places,
people still use such jugs to carry and
store water.

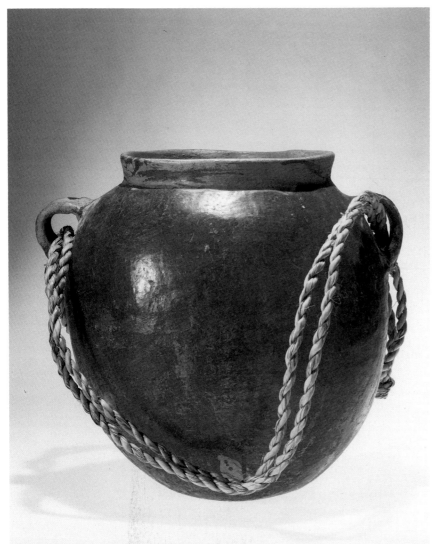

75.
Water jug
Puebla
Clay: single-fired, with a coat of red
iron-oxide
27 x 29
1985/1.198 A

76.
Majolica platter
Guanajuato, Guanajuato
Clay: fired, brush-painted, glazed
38.5 (diam.)
1985/1.82 A

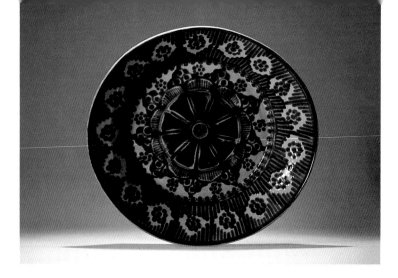

77–79.
Platters
Guanajuato, Guanajuato
Clay: fired, decorated with graffito, glazed
Plate 77:
44.5 x 28 x 28 1985/1.284 C
Plate 78:
30.5 (diam.) 1985/1.91
Plate 79:
44.5 x 28 x 28 1985/1.284 B

Nineteenth-century majolica ware
was revived by ceramist Gorky
González in the latter part of this cen-
tury. The lower portion of the plat-
ters exhibits traditional majolica colors
and designs.

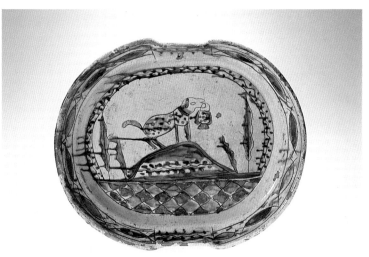

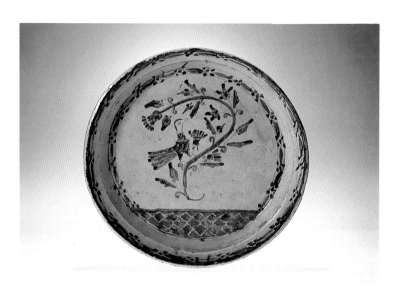

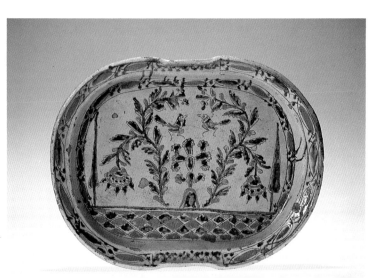

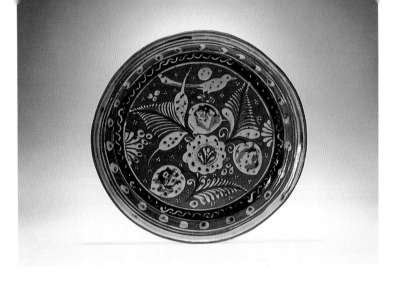

80.
Plate
Tonalá, Jalisco
Clay: moldmade, fired, brush-painted, glazed
28.2 x 2.5
1985/1.305 A

81–83.
Platters
Patamban, Michoacán
Clay: formed on a mold, fired, brush-painted, glazed
Plate 81:
33 x 5 1985/1.302
Plate 82:
41.2 x 32.4 1985/1.272
Plate 83:
30.5 (diam.) 1985/1.74

Glassware

After Spaniards brought the art of glassmaking to Mexico, production centered in the cities of Mexico and Puebla. Today's industry is wide-spread, and the best factories are in Guadalajara, Tlaquepaque, and Mexico City. As illustrated here, the variety of colors and forms created by glassware producers is infinite, particularly for forms of utlitarian use: jugs, pitchers, goblets, glasses, and bottles.

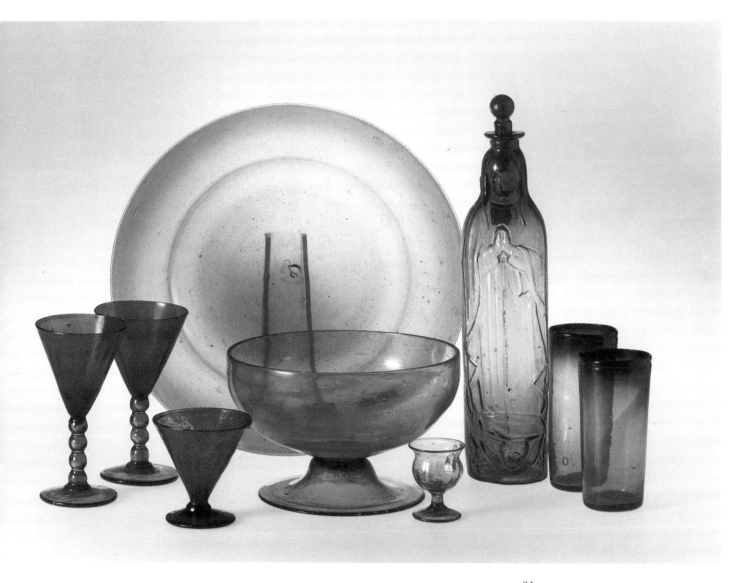

84.
Goblets, plate, fruit compote, bottle, brandy
 glass, and glasses
Guadalajara, Jalisco
Blown glass: hand- and moldmade
Left to right:

16 x 8.2	1985/1.4 C–E
9 x 8.2	1985/1.2 B
39.2 (diam.)	1985/1.6
24 x 15.2 x 8.2	1985/1.8
7 x 15.2	1985/1.1 E
34.2 x 8.5	1985/1.9
14 x 6	1985/1.3 E, D

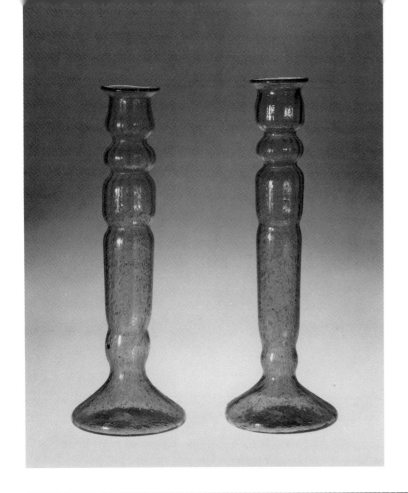

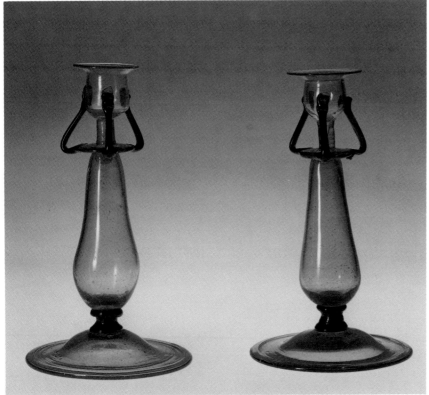

85–86.
Candle holders
Guadalajara, Jalisco
Blown glass
Plate 85:
24.2 x 13.5 (each) 1985/1.7 A–B
Plate 86:
33 x 11.5 (each) 1985/1.5 A–B

These utilitarian candle holders are of excellent manufacture. No such delicate items are made today in any of Mexico's factories.

Lacquerware

Lacquer is a durable coating that waterproofs and decorates objects of wood or other organic material for domestic or ornamental use. To make it, Mexican artisans combine soil and industrial or natural pigments with a fixative, which can be *chía* oil (lime-leaved sage), linseed oil, or *aje* (the fat of a particular worm).

The technique is always the same: first, the artisan applies a fixative to the wood, then a mixture of dirt and pigments. The object is rubbed or burnished by hand to smooth the coating and fix it to the surface.

During the pre-Hispanic period, lacquerware was made throughout Mesoamerica and was very common in Mexico. It is therefore one of the most traditional and oldest kinds of folk art in Mexico.

Lacquerware in the Rockefeller collection provides magnificent examples of the different decorative techniques still in use. There are incised and gilded pieces from Olinalá, inlaid work from Uruapan, and gilded lacquerware from Pátzcuaro. Also, there are valuable examples of lacquerware from Quiroga which have now disappeared.

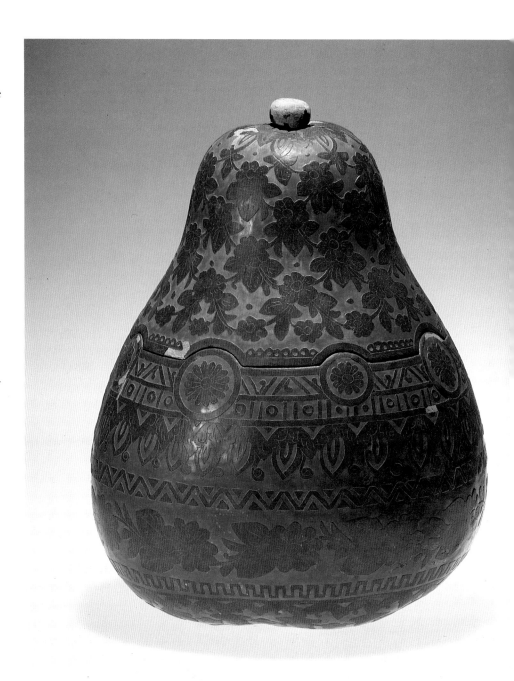

87.
Powder box
Olinalá, Guerrero
Gourd: lacquered in the *rayado* (incised) style,
decorated with traditional floral motifs
28 x 22.5
1985/1.261

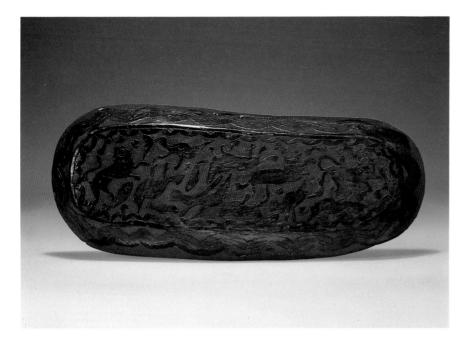

88.
Tray
Olinalá, Guerrero
Wood: of antique form, lacquered in the *rayado* (incised) style, with traditional colors and motifs of antique design
31 x 12.5 x 2.5
1985/1.129 B

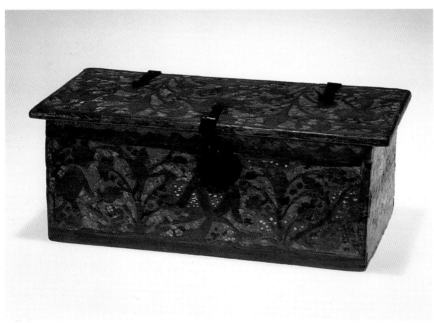

89.
Chest
Olinalá, Guerrero
Wood: lacquered in the *rayado* (incised) style; hand-forged iron hardware
29.5 x 15.2 x 11.5
1985/1.36

Olinalá is presently the most important lacquerware center in Mexico and the Americas. It produces two styles: *dorado* (gilded); and *rayado* (incised), which is the style of these pieces. The forms usually decorated are boxes of various sizes of fragrant *linaloe* wood, calabash cups, powder boxes, gourds, sewing boxes, basins made from the dried shells of various species of squash, trays, and chests.

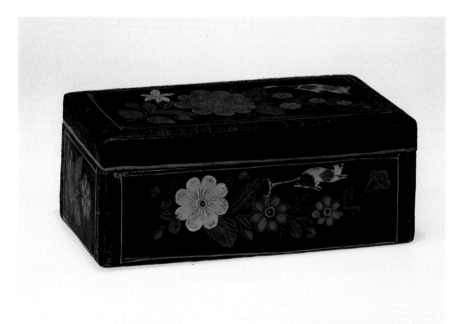

90.
Pesetera (box)
Olinalá, Guerrero
Wood: lacquered in black, brush-painted
7.7 x 10.2 x 18.2
1985/1.22

This box's name derives from its original price: a *peseta*, which was then about twenty-five cents. *Tostonera* boxes likewise used to cost a *tostón* (fifty cents).

91–92.
Chests
Olinalá, Guerrero
Pine wood: lacquered in the *dorado* (gilded)
style, brush-painted
Plate 91:
38.2 x 78.5 x 46 1985/1.275
Plate 92:
71 x 35.5 x 35.5 1985/1.276

The lids are in the style called *de
caballito* (curved), and the motifs are
traditional. The interiors of the chests
are varnished.

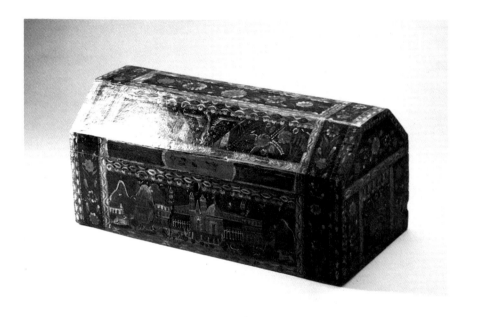

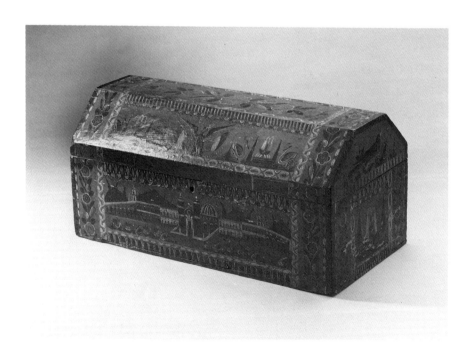

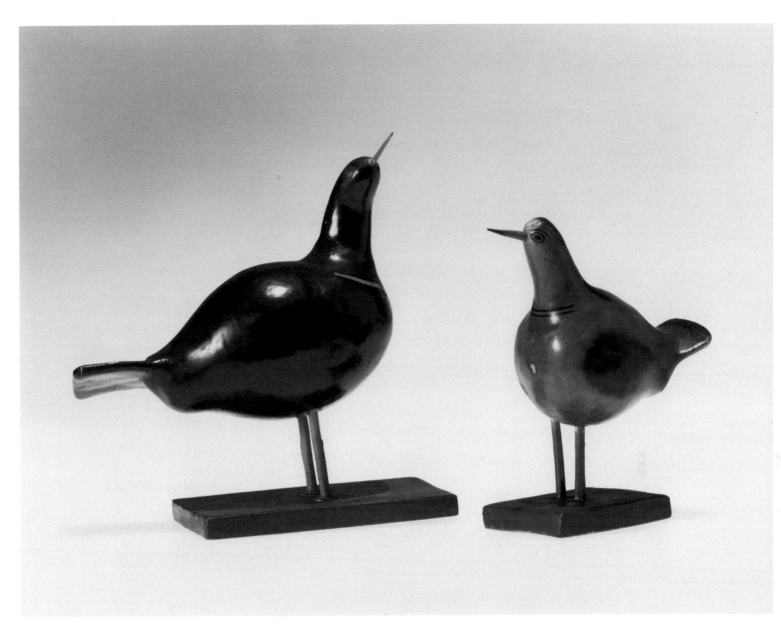

93.
Birds
Olinalá, Guerrero
Gourd: lacquered, veneered, brush-painted
14 x 6.5 x 12.5 (avg.)
1985/1.264 A–B

These figures are fixed to a lacquered
wood base. The birds' feet are deline-
ated by brushwork, and their beaks
are made of thorns. Pieces of this
superior quality are no longer made.
Instead, producers use a soft wood
referred to as *de pipirucha*.

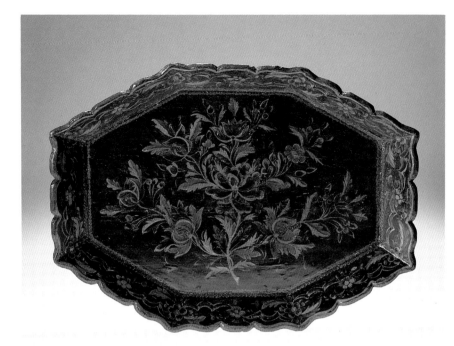

94–95.
Trays
Pátzcuaro, Michoacán
Wood: oil-painted, varnished, gold leaf
applied with a fixative
Plate 94:
48.2 x 35.5 x 5 1985/1.126
Plate 95:
19.8 x 2.5 1985/1.128

These trays are significant examples of
antique lacquerware. Their forms,
decoration, and motifs are traditional.

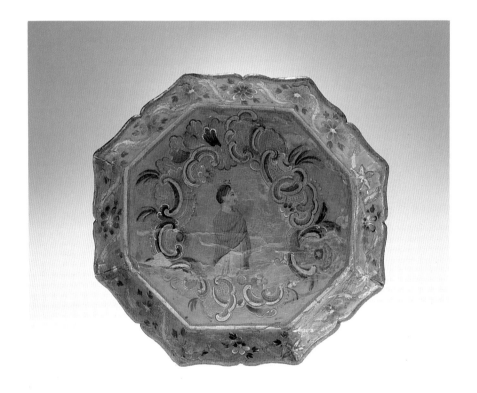

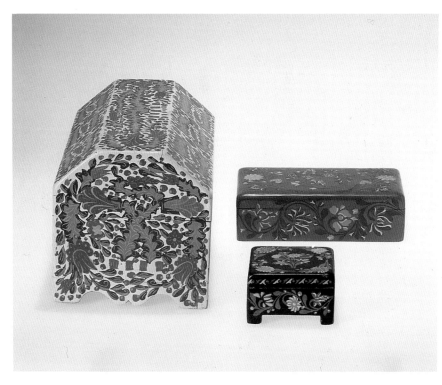

96.
Chest and boxes
Uruapan, Michoacán
Wood: lacquered in the *embutido* or *incrustado*
(inlaid) style, varnished
Left to right:
35 x 7.5 x 7.5 1985/1.24
16 x 25 x 14 1985/1.21
4.5 x 16 x 9.3 1985/1.23

The colors of the lacquer and decorative elements in these pieces are traditional, as is the dark brown background of the long box. The decoration of the chest is rare and does not correspond to a traditional style.

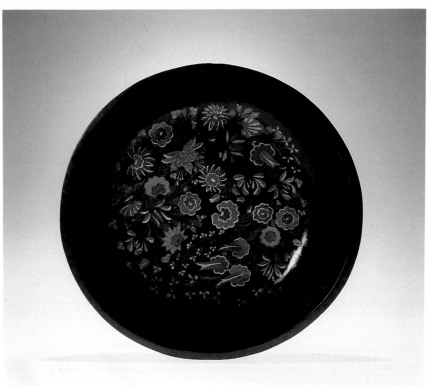

97.
Tray
Uruapan, Michoacán
Tzirimo wood: lacquered in the inlaid style,
with antique floral designs
31.5 x 6.5
1985/1.127

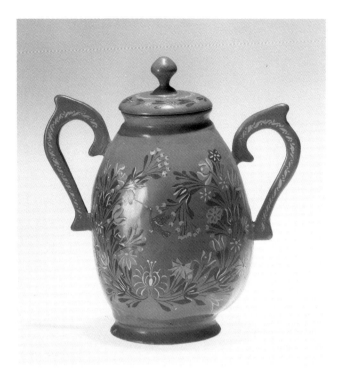

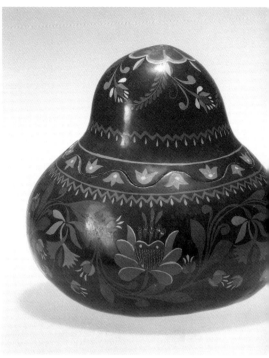

98.
Sugar bowl
Uruapan, Michoacán
Gourd with wooden top, handles, and base:
lacquered in the inlaid style, with traditional
floral motif
22.5 x 25
1985/1.57 A, B

99.
Powder box
Uruapan, Michoacán
Gourd: inlaid lacquer
21.5 x 21.5
1985/1.285 A, B

To achieve the traditional floral decoration on this container, the artisan applied the color black to the gourd, then incised designs with sharp instruments. Next, after scraping out the incised section to reveal the gourd's surface, the artist added a different color in the hollows.

This process requires a great deal of time and effort. To avoid one color staining the other—particularly when very fine lines are applied—each coat must be completely dry before the next is applied.

The gourd, a traditional form par excellence, has been used since the pre-Hispanic period. Today, it can be found as a vessel for drink or food, a measuring device, and part of feminine accessories. That such utensils continue to be manufactured from the gourd demonstrates their rootedness in the culture and their usefulness in the daily life of Mexicans.

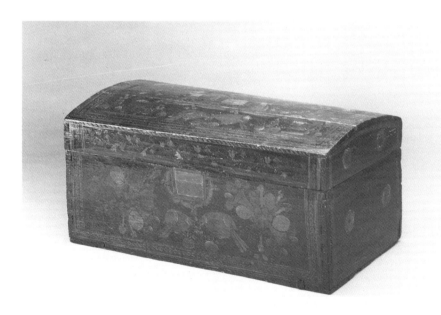

100.
Chest
Quiroga, Michoacán
Wood: lacquered, with brush-painted,
antique-style motifs
33 x 63.5 x 38.2
1985/1.273

Clothing

The collection's magnificent textiles include sarapes and other outerwear such as the classic *rebozos* and *gabánes*, which are finely woven from wool and cotton. This type of clothing is still produced today, but it is impossible to find the same designs and fine weave. Other objects in the collection are skirts, shirts, bags, and *huaraches* (leather sandals).

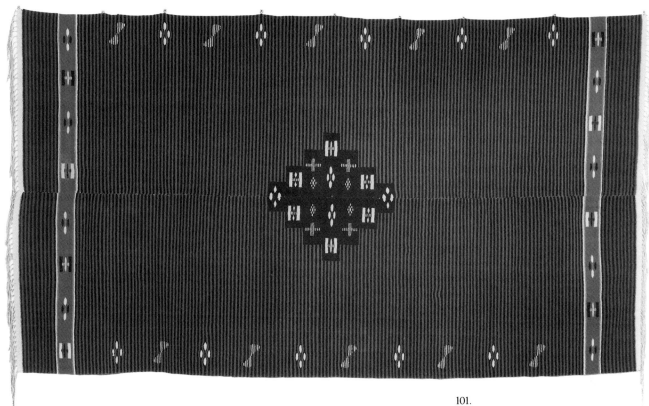

101.
Gabán (man's outer garment)
State of Mexico
Wool: woven on a *lanzadera* (pedal loom)
109 x 178.5
1985/1.337

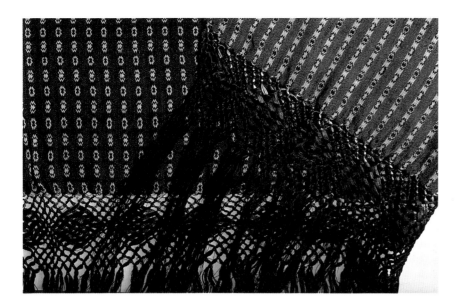

102.
Rebozo (shawl)
Provenance uncertain
Silk with cotton fringe: woven of very fine
thread, reversible shawl
43 x 160
1985/1.338

103.
Huichol *morral* (bag)
Nayarit
Muslin: embroidered with wool yarn
24 x 23
1985/1.342 B

The embroidery on the Huichol
Indian bag is a variation of the
cross-stitch, a technique borrowed in
colonial days from the Spaniards. The
main pattern, the orange *peyote* design,
is inspired by religious and magical
concerns.

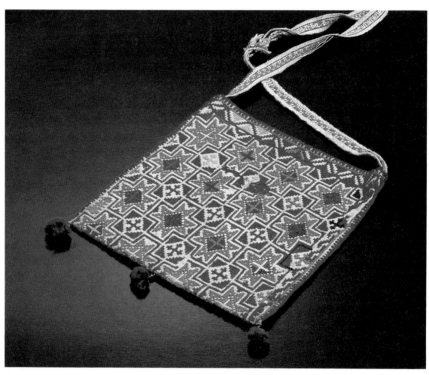

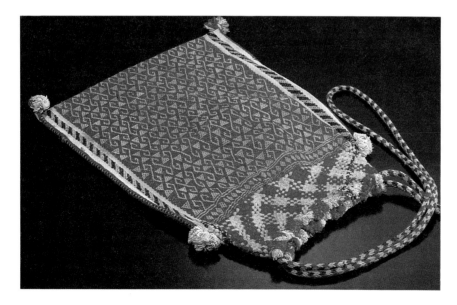

104.
Otomí *morral* (bag)
Provenance uncertain
Wool: woven on a backstrap loom
41 x 31
1985/1.342 D

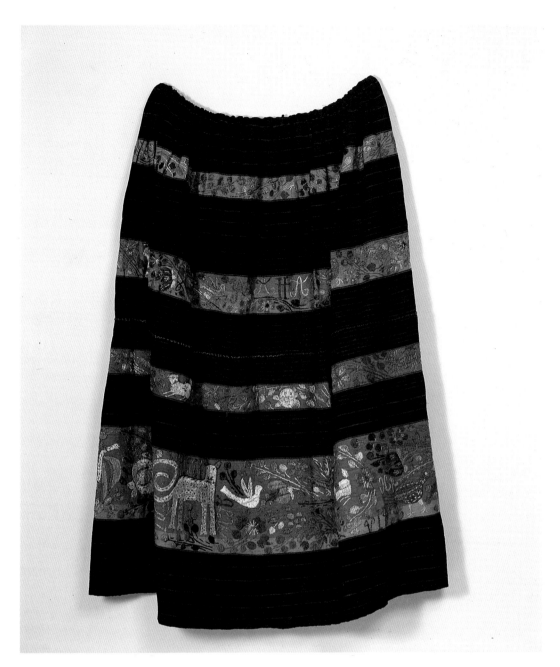

105.
Nahua skirt
Acatlán, Guerrero
Wool: woven on a backstrap loom, with silk
thread embroidery
248 x 104
1985/1.332

Checklist of the Collection

Note: All works are 20th century unless otherwise noted. All measurements are in centimeters; height precedes width precedes depth, unless otherwise noted.

Brandy glasses
Avalos Workshop
Guadalajara, Jalisco
Handblown glass
7 × 15.2
1985/1.1 A–F

Glasses
Avalos Workshop
Guadalajara, Jalisco
Handblown glass
9 × 8.2
1985/1.2 A–F

Glasses
Avalos Workshop
Guadalajara, Jalisco
Handblown glass
14 × 6
1985/1.3 A–E

Goblets
Avalos Workshop
Guadalajara, Jalisco
Handblown glass
16 × 8.2
1985/1.4 A–F

Candle holders
Guadalajara, Jalisco
Handblown glass
33 × 11.5
1985/1.5 A–B

Plate
Guadalajara, Jalisco
Handblown glass
39.2 (diam.)
1985/1.6

Candle holders
Guadalajara, Jalisco
Handblown glass
24.2 × 13.5
1985/1.7 A–B

Fruit compote
Guadalajara, Jalisco
Handblown glass
24 × 15.2 × 8.2
1985/1.8

"Guadalupe" bottle
Guadalajara, Jalisco
Moldmade glass
34.2 × 8.5
1985/1.9

Fruit tablepieces
Provenance uncertain
Silver holloware
7.5 × 10.2 × 10.2
1985/1.10 A–D

Dolls
San Cristobal de las Casas, Chiapas
Wax, cloth, beads
15 × 13.5 (avg.)
1985/1.11 A–D

Incense burners
Izúcar de Matamoros, Puebla
Varnished polychrome ceramic
38 × 18 × 12.7 (avg.)
1985/1.12 A–B

Pair of figures
Flores family
Izúcar de Matamoros, Puebla
Varnished polychrome ceramic
5.2 × 12.7 × 7.7 (avg.)
1985/1.13 A–B

Pig banks
Santa Cruz de las Huertas, Jalisco
Varnished polychrome ceramic
10.3 × 10.3 × 7.7
1985/1.14 A–D

Pig whistle banks
Santa Cruz de las Huertas, Jalisco
Varnished polychrome ceramic
7.7 × 7.7 × 5
1985/1.15 A–P

Popote (straw) painting
State of Mexico
Board, glue, broomstraw
18.2 × 12.7
1985/1.16

Popote (straw) painting
State of Mexico
Board, glue, broomstraw
18.2 × 12.7
1985/1.17

Jaguar mask
Olinalá, Guerrero
Lacquered polychrome wood
30.5 × 18.2 × 18.2
1985/1.18

Mask molds
Celaya, Guanajuato
Ceramic
15.2 × 12.5 (avg.)
1985/1.19 A–I

Small boxes
Paracho, Michoacán
Polychrome carved wood
10.2 × 15.2 × 10
1985/1.20 A–B

Box with key
Uruapan, Michoacán
Lacquered polychrome wood
16 × 25 × 14
1985/1.21

Box
Olinalá, Guerrero
Lacquered polychrome wood
7.7 × 10.2 × 18.2
1985/1.22

Box
Uruapan, Michoacán
Lacquered polychrome wood
4.5 × 16 × 9.3
1985/1.23

Box
Uruapan, Michoacán
Lacquered polychrome wood
3.5 × 7.5 × 7.5
1985/1.24

Sarape
Chiconcuac, state of Mexico
Woven wool
194.6 × 177
1985/1.25

Box
Provenance uncertain
Painted gold-leafed wood, mirror
10 × 7.5 × 7.5
1985/1.26

Sarape
Provenance uncertain
Woven wool
147.5 × 239.5
1985/1.27

Jar
Patamban, Michoacán
Burnished slipped polychrome ceramic
30.5 × 30.5
1985/1.28

Skeleton masks
Celaya, Guanajuato
Polychrome moldmade papier-mâché
20 × 17.5 × 9 (avg.)
1985/1.29 A–C

Sarape
Provenance uncertain
Woven wool
193.6 × 132.5
1985/1.30

Sarape
Tlaxcala
Woven wool
120 × 203.6
1985/1.31

Poncho
Provenance uncertain
Woven wool
198.5 × 179.5
1985/1.32

Cups
Provenance uncertain
Polychrome ceramic
6.5 × 5
1985/1.33 A–F

Sarape
Provenance uncertain
Woven wool
142.7 × 209
1985/1.34

Sarape
Provenance uncertain
Woven wool
203.6 × 66
1985/1.35

Chest
Olinalá, Guerrero
Lacquered polychrome wood, metal
29.5 × 15.2 × 11.5
1985/1.36

Sarape
Provenance uncertain
Woven wool
215 × 127
1985/1.37

Jar
Patamban, Michoacán
Ceramic with hand-painted animal design
19 × 19
1985/1.38

Sarape
Provenance uncertain
Woven wool
56 × 238
1985/1.39

Napkin
Provenance uncertain
Embroidered cotton
46 × 48
1985/1.40

Caimán masks
Celaya, Guanajuato
Polychrome moldmade papier-mâché
24 × 20 × 17.5
1985/1.41 A–B

Skeleton mask
Celaya, Guanajuato
Polychrome moldmade papier-mâché
17.5 × 12.5 × 16
1985/1.42

Miniature cups
Provenance uncertain
Glazed polychrome ceramic
3 × 2.5
1985/1.43 A–T

Huipiles (blouses)
Provenance uncertain
Embroidered silk on cotton
Various sizes
1985/1.44 A–C

Soldier bank
Atzompa, Oaxaca
Glazed monochrome ceramic
17.5 × 18.3
1985/1.45

Bull bank
Atzompa, Oaxaca
Glazed monochrome ceramic
22.5 × 14
1985/1.46

Deer figure
Atzompa, Oaxaca
Glazed incised ceramic
25 × 12.5
1985/1.47

Chía animal
Atzompa, Oaxaca
Glazed incised ceramic
15.2 × 10 × 8.5
1985/1.48

Pig bank
Texcoco, state of Mexico
Glazed monochrome ceramic
9 × 9
1985/1.49

Water bottle
Tonalá, Jalisco
Burnished ceramic with gold and
 silver paint
32 × 17.5
1985/1.50

Water jug
Tonalá, Jalisco
Polychrome ceramic
22 × 15.2
1985/1.51

Vessel
Toluca, Mexico
Glazed monochrome ceramic
15.2 × 10
1985/1.52

Water bottle
Provenance uncertain
Glazed wheel-thrown ceramic
30 × 19
1985/1.53

Incense burner
Ocotlán de Morelos, Oaxaca
Polychrome ceramic
22.5 × 22.5
1985/1.54

Incense burner
Ocotlán de Morelos, Oaxaca
Polychrome ceramic
15.2 × 12.5
1985/1.55

Cups
Provenance uncertain
Polychrome ceramic
6.2 × 6.2
1985/1.56 A–F

Sugar bowl
Uruapan, Michoacán
Lacquered polychrome gourd
22.5 x 25
1985/1.57 A, B

Painting
Puebla
Oil on wood
20 × 16.5
1985/1.58

Candelabra
Texcoco, state of Mexico
Glazed moldmade ceramic
20 × 15.2 × 14
1985/1.59

Candelabra
Texcoco, state of Mexico
Glazed moldmade ceramic
19 × 15.2
1985/1.60

Lion vessel
Metepec, state of Mexico
Glazed moldmade monochrome
 ceramic
22.5 × 22.5 × 12.5
1985/1.61

Fish bank
Texcoco, state of Mexico
Polychrome ceramic
20 × 10
1985/1.62

Fish bank
Metepec, state of Mexico
Polychrome ceramic
12.5 × 23.5 × 7.5
1985/1.63

Old man mask
Provenance uncertain
Polychrome carved wood, fur,
 ixtle
35.5 × 20
1985/1.64

Old man mask
Pátzcuaro, Michoacán
Carved wood
35.5 × 14
1985/1.65

Incense burner
Ocotlán de Morelos, Oaxaca
Polychrome ceramic
10 × 7.5
1985/1.66

Incense burner
Ocotlán de Morelos, Oaxaca
Ceramic
12.5 × 10
1985/1.67

Plate
Patamban, Michoacán
Glazed polychrome ceramic
4.5 × 33
1985/1.68

Platter
Patamban, Michoacán
Glazed polychrome ceramic
3.6 × 28 × 22.5
1985/1.69

Pot
Patamban, Michoacán
Glazed polychrome ceramic
43 × 19 (avg.)
1985/1.70 A–B

Pot
Tonalá, Jalisco
Burnished polychrome ceramic
44.5 × 52
1985/1.71

Anthropomorphic pitcher
Santa Fe de la Laguna,
 Michoacán
Moldmade polychrome ceramic
19.5 × 14
1985/1.72

Plate
Valle de Bravo, state of Mexico
Glazed moldmade ceramic
31.7 (diam.)
1985/1.73

Platter
Patamban, Michoacán
Glazed polychrome ceramic
30.5 (diam.)
1985/1.74

Bowl
Patamban, Michoacán
Glazed monochrome ceramic
33 × 25
1985/1.75

Bowl
Puebla, Puebla
Glazed polychrome ceramic
34.2 × 7.5
1985/1.76

Plate
Tuluca, state of Mexico
Glazed monochrome ceramic
22.5 (diam.)
1985/1.77

Pitcher
Santa Fe de la Laguna,
 Michoacán
Glazed moldmade polychrome
 ceramic
36.5 × 22.5 × 12.5
1985/1.78

Candle holder and pitcher
Santa Fe de la Laguna,
 Michoacán
Drip-glazed ceramic
24 × 11.5 × 4 (avg.)
1985/1.79 A–B

Lion vase
Michoacán
Drip-glazed ceramic
10 × 15.2
1985/1.80

Majolica jar with lid
Guanajuato, Guanajuato
Glazed polychrome ceramic
25 × 22.5
1985/1.81 A–B

Majolica platter and jar with lid
Guanajuato, Guanajuato
Enameled polychrome ceramic
38.5 (diam.); 24 × 19
1985/1.82 A–C

Squash pot
Provenance uncertain
Drip-glazed moldmade ceramic
17.5 × 11.4
1985/1.83

Duck candle holder
Provenance uncertain
Drip-glazed moldmade ceramic
22.2 × 17.5
1985/1.84

Bowl
Dolores Hidalgo, Guanajuato
Glazed polychrome ceramic
8.8 × 21.5
1985/1.85

Talavera poblana (majolica) bowl
Puebla, Puebla
Glazed enameled polychrome
 ceramic
16.5 × 7
1985/1.86

Talavera poblana (majolica) jar
 with lid
Puebla, Puebla
Glazed enameled monochrome
 ceramic
30.5 × 20 × 5
1985/1.87 A–B

Talavera poblana (majolica) vase
Puebla, Puebla
Glazed enameled monochrome
 ceramic
21.5 × 15.2
1985/1.88

Talavera poblana (majolica) vase
Guanajuato, Guanajuato
Glazed enameled monochrome
 ceramic
26 × 20
1985/1.89

Talavera bowl
Puebla, Puebla
Glazed monochrome ceramic
25 × 11.4
1985/1.90

Majolica platter
Guanajuato, Guanajuato
Polychrome incised ceramic
30.5 (diam.)
1985/1.91

Bowl
Jalisco
Glazed polychrome ceramic,
 pressed stamped decoration
24.7 × 12
1985/1.92

Pitcher
Michoacán
Glazed polychrome ceramic
17.5 × 14
1985/1.93

Sugar bowl with lid
Michoacán
Glazed polychrome ceramic
12.5 × 8.8
1985/1.94 A–B

Pitcher
Michoacán
Glazed polychrome ceramic
13.5 × 14.5
1985/1.95

Plates
Michoacán
Glazed ceramic
28.5 (diam.)
1985/1.96 A–B

Platter
Michoacán
Glazed polychrome ceramic
20 × 16.5
1985/1.97

Pitcher
Metepec, state of Mexico
Glazed, moldmade polychrome
 ceramic
24 × 19
1985/1.98

Pot
Tecomatepec, state of Mexico
Polychrome ceramic
29.3 × 24
1985/1.99

Head banks
Tonalá, Jalisco
Polychrome moldmade ceramic
17.5 × 14 × 15.2 (avg.)
1985/1.100 A–C

Pig
Tonalá, Jalisco
Burnished moldmade
 polychrome ceramic
22.5 × 22.5
1985/1.101

Water bottle
El Rosario, Jalisco
Burnished polychrome ceramic
20 × 17.5
1985/1.102

Water bottle
Tonalá, Jalisco
Burnished polychrome ceramic
33.5 × 10
1985/1.103

Vase
Tonalá, Jalisco
Burnished polychrome ceramic
22.5 × 14
1985/1.104

Duck vessel
Tonalá, Jalisco
Burnished moldmade
 polychrome ceramic
38.2 × 21.5
1985/1.105

Cups
Tonalá, Jalisco
Burnished polychrome ceramic
11.4 × 9.5
1985/1.106 A–B

Incense burner
Tonalá, Jalisco
Burnished polychrome ceramic
21 × 19
1985/1.107

Vase
Tonalá, Jalisco
Burnished polychrome ceramic
25 × 21.5
1985/1.108

Jar
Tonalá, Jalisco
Burnished moldmade
 polychrome ceramic
71 × 50
1985/1.109

Talavera dinner plate
Puebla, Puebla
Glazed polychrome ceramic
23.3 (diam.)
1985/1.110

Plate
Puebla
Glazed polychrome ceramic
23.3 (diam.)
1985/1.111

Plate
Puebla
Glazed polychrome ceramic
16.5 (diam.)
1985/1.112

Plate
Provenance uncertain
Glazed polychrome ceramic
32.2 × 28.8
1985/1.113

Platter
State of Mexico
Glazed polychrome ceramic
31.7 × 30.5
1985/1.114

Pot
Provenance uncertain
Glazed polychrome ceramic
31 × 7.5
1985/1.115

Bowl
Oaxaca
Glazed polychrome ceramic
5 × 17.5
1985/1.116

Pitcher
Valle de Bravo, state of Mexico
Glazed polychrome ceramic
9.8 × 11.4
1985/1.117

Cup
Valle de Bravo, state of Mexico
Glazed polychrome ceramic
12.5 × 8.8
1985/1.118

Plate
Tolimán, Guerrero
Glazed polychrome ceramic
20 × 5.6
1985/1.119

Plate
Veracruz
Glazed polychrome ceramic
16.5 (diam.)
1985/1.120

Pulque jar
Metepec, state of Mexico
Glazed polychrome ceramic
40.5 × 33.5
1985/1.121

Water vessel
San Agustín de las Flores,
 Guerrero
Polychrome ceramic
40.5 × 33
1985/1.122

Platters
Michoacán
Glazed polychrome ceramic
33 × 25 × 6.5
1985/1.123 A–B

Jar
Tolimán, Guerrero
Polychrome ceramic
62 × 51
1985/1.124

Tray
Uruapan, Michoacán
Lacquered polychrome inlaid
 wood
57.2 (diam.)
1985/1.125

Octagonal tray
Pátzcuaro, Michoacán
Lacquered polychrome wood
48.2 × 35.5 × 5
1985/1.126

Tray
Uruapan, Michoacán
Lacquered polychrome gourd
31.5 × 6.5
1985/1.127

Trays
Pátzcuaro, Michoacán
Lacquered polychrome wood
 with gold leaf
19.8 × 2.5 (avg.)
1985/1.128 A–B

Tray
Olinalá, Guerrero
Lacquered polychrome incised
 wood
31 × 12.5 × 2.5
1985/1.129

Sampler
State of Mexico
Embroidered cotton
42 × 29.3
1985/1.130

Sampler
State of Mexico
Embroidered cotton
33 × 13.3
1985/1.131

Sampler
State of Mexico
Embroidered silk
31.7 × 32.3
1985/1.132

Santo
Provenance uncertain
Polychrome carved wood with
 gold leaf
52.7 × 17.5
1985/1.133

Madonna
Provenance uncertain
Carved gessoed wood with gold
 leaf
30.5 × 14
1985/1.134

Painting
Provenance uncertain
Oil on canvas
62 × 86.5
1985/1.135

Devil mask
Provenance uncertain
Polychrome carved wood
43.5 × 16.5 × 16.5
1985/1.136

Vases
Santa Fe de la Laguna,
 Michoacán
Glazed polychrome ceramic
19.5 × 18.3
1985/1.137 A–B

Monkey figure
San Bartolo Coyotepec, Oaxaca
Burnished blackware
17.5 × 12.5
1985/1.138

Owl whistle
San Bartolo Coyotepec, Oaxaca
Burnished blackware
21 × 12.5
1985/1.139

Pot
Tolimán, Guerrero
Slipped polychrome ceramic
35.5 × 34.2
1985/1.140

Pitcher
Barrio de la Luz, Puebla, Puebla
Glazed polychrome ceramic
 with appliquéd decoration
48.3 × 34.2
1985/1.141

Jug
Oaxaca
Burnished ceramic
30.5 × 20
1985/1.142

Pot
Guanajuato
Burnished slipped ceramic
30.5 × 30.5
1985/1.143

Pot
Guerrero
Polychrome ceramic
39.2 × 30.5
1985/1.144

Cinch
Provenance uncertain
Braided cordage, metal
72.3 × 12.5
1985/1.145

Bit
Provenance uncertain
Braided horsehair
236 × 30
1985/1.146

Huaraches
Jalisco
Leather grommetwork
30.5 (avg.)
1985/1.147 A–L

Chest
Olinalá, Guerrero
Lacquered polychrome wood
40.5 × 83.5 × 40.5
1985/1.148

Candle holders
Provenance uncertain
Tin
28 × 12.5
1985/1.149 A–D

Wristband
Guanajuato
Hand-stitched leather, yarn
26 × 4
1985/1.150

Jug
San Bartolo Coyotepec, Oaxaca
Burnished incised blackware
42 × 35.5
1985/1.151

Jug
San Bartolo Coyotepec, Oaxaca
Burnished blackware
30.5 × 29.3
1985/1.152

Colander
San Bartolo Coyotepec, Oaxaca
Burnished blackware
25 × 33
1985/1.153

Plate
Santa Clara del Cobre,
 Michoacán
Hammered copper
16.5 × 5
1985/1.154

Plate
Santa Clara del Cobre,
 Michoacán
Hammered copper
14.5 × 3.2
1985/1.155

Toy chair
Provenance uncertain
Painted wood, cordage
55 × 28 × 22.5
1985/1.156

Mirror frame
Puebla
Tin
38.2 × 40.5
1985/1.157

Fruit pieces
Telolapan, Guerrero
Carved painted balsa wood
20 × 10 (avg.)
1985/1.158

Fruit vendors
Panduro family
Tlaquepaque, Jalisco
Polychrome moldmade ceramic
17 × 12.5 × 10
1985/1.159 A–B

Woman-shaped whistle
Tlaquepaque, Jalisco
Polychrome moldmade ceramic
12.5 × 6.5
1985/1.160

Dolls
Ocotlán de Morelos or Juchitán,
 Oaxaca
Polychrome ceramic
15.2 × 7.5 (largest doll)
1985/1.161 A–E

Mini pottery
Puebla
Glazed polychrome ceramic
11.4 × 6.5 (avg.)
1985/1.162 A–G

Cat bank
Julián Acero
Santa Cruz de las Huertas,
 Jalisco
Polychrome moldmade ceramic
20 × 17.5 × 10
1985/1.163

Animal figures
Ocotlán, Oaxaca
Polychrome ceramic
6.5 × 5.5 (avg.)
1985/1.164 A–B

Candle holders
Ocotlán, Oaxaca
Polychrome ceramic
10 × 10 × 6.5
1985/1.165

Horse and rider figures
Ocotlán, Oaxaca
Monochrome ceramic
11.4 × 9.5 (avg.)
1985/1.166 A–B

Plate
Michoacán
Glazed polychrome ceramic
11.4 (diam.)
1985/1.167

Toy stringed musical instrument
Michoacán
Polychrome wood, wire
16 × 7
1985/1.168

Toy stringed musical instrument
Michoacán or Chiapas
Polychrome wood, wire
25 × 12.2 × 5
1985/1.169

Set of kitchen utensils
Michoacán
Incised wood
24 × 3 (avg.)
1985/1.170 A–C

Spoon
Michoacán
Carved wood
16 × 2.5
1985/1.171

Spoon and fork
San Antonio la Isla, Jalisco
Turned carved wood
30.5 × 5.5 (avg.)
1985/1.172 A–B

Comb
Oaxaca
Carved wood
9.5 × 7
1985/1.173

Owl whistle
Jalisco
Polychrome ceramic
8.8 × 8.8
1985/1.174

Flute
Jalisco
Polychrome ceramic
20 × 1.8
1985/1.175

Bell figure
San Bartolo Coyotepec, Oaxaca
Burnished blackware, wire
11.4 × 8.8
1985/1.176

Shepherd and flock
San Pedro Tlaquepaque, Jalisco
Polychrome ceramic
11.4 × 7.5
1985/1.177

Merry-go-round
San Pedro Tlaquepaque, Jalisco
Polychrome ceramic
12.5 × 7.5
1985/1.178 A–B

Horse
Celaya, Guanajuato
Polychrome moldmade papier-
 mâché
16 × 13.3
1985/1.179

Puppets
Provenance uncertain
Polychrome wood, cloth
43 × 11.4
1985/1.180 A–B

Pull toy
Guerrero
Polychrome gessoed wood
39.5 × 5
1985/1.181

Cactus
Jalisco
Polychrome ceramic
15.2 × 12.5 × 7.5
1985/1.182

Woman vendor
Jalisco
Varnished polychrome ceramic
5 × 3.6
1985/1.183

Snake figures
San Pedro Tlaquepaque, Jalisco
Polychrome ceramic
6.5 × 7.5
1985/1.184 A–B

Fruit-shaped banks
Tonalá, Jalisco
Varnished polychrome ceramic
18 (avg. circ.)
1985/1.185 A–X

Cane
Toluca, state of Mexico
Polychrome carved wood
94 × 2.5
1985/1.186

Riding crop
Tlaxcala
Polychrome carved wood
63.5 × 1.2
1985/1.187

Toy brooms
Provenance uncertain
Dyed tied plant fibers
14 × 7.5 (avg.)
1985/1.188 A–C

Crocodile figures
Amatenango del Valle, Chiapas
Polychrome ceramic
10 × 38.2 × 7.5 (avg.)
1985/1.189 A–B

Anthropomorphic basins
Isthmus of Tehuantepec, Oaxaca
Incised ceramic
73.5 × 33 × 35.5 (avg.)
1985/1.190 A–C

Vase
Tonalá, Jalisco
Burnished incised ceramic
25 × 19
1985/1.191

Floral decorations
Provenance uncertain
Foil paper
25 × 10 (avg.)
1985/1.192

Candle holder
Provenance uncertain
Tin
21.5 × 25
1985/1.193

Jar
Patamban, Michoacán
Glazed monochrome ceramic
28 × 29.3
1985/1.194

Devil
Celaya, Guanajuato
Polychrome moldmade papier-mâché
56.5 × 36.5
1985/1.195

Bull-shaped pyrotechnic
armature
Oaxaca
Polychrome papier-mâché, reed
68.5 × 71
1985/1.196

Anthropomorphic mask
Guerrero
Polychrome carved wood
15.2 × 14
1985/1.197

Water jugs
Various origins
Ceramic
Various sizes
1985/1.198 A–G

Bowls
Huejutla, Hidalgo
Ceramic
Various sizes
1985/1.199 A–B

Flower pot
Provenance uncertain
Glazed polychrome ceramic
22.2 × 19
1985/1.200

Pitcher
Tonalá, Jalisco
Burnished polychrome ceramic
40.5 × 22.5 × 8.8
1985/1.201

Plate
Tonalá, Jalisco
Burnished polychrome ceramic
32.5 (diam.)
1985/1.202

Tiles
Pío Solís
Tonalá, Jalisco
Burnished polychrome ceramic
19 x 19
1985/1.203 A–C

Head bank
Tonalá, Jalisco
Burnished polychrome ceramic
18.5 × 16.5
1985/1.204

Bowl
Tolimán, Guerrero
Polychrome ceramic
28 × 13.2
1985/1.205

Doll
Ameyaltepec, Guerrero
Polychrome ceramic
73.5 × 15.2
1985/1.206

Soup bowls
Provenance uncertain
Glazed polychrome ceramic
19 × 9.5 (avg.)
1985/1.207 A–D

Bowls
Provenance uncertain
Glazed polychrome ceramic
5 × 12.5 (avg.)
1985/1.208 A–E

Candle holders
Tzintzuntzan, Michoacán
Glazed molded ceramic
17 × 15.2
1985/1.209 A–B

Square plate
Tzintzuntzan, Michoacán
Glazed ceramic
20 × 15.2
1985/1.210

Casseroles
Provenance uncertain
Glazed polychrome ceramic
30.5 × 16.5 (avg.)
1985/1.211 A–E

Animal figures
Provenance uncertain
Polychrome ceramic
10 × 10 × 10 (avg.)
1985/1.212 A–J

Brazier
Acatlán, Puebla
Buff ceramic
64 × 40.5
1985/1.213

Candelabra
Herón Martínez
Acatlán, Puebla
Burnished ceramic
40.5 × 38.2
1985/1.214

Zoomorphic bowl
Herón Martínez
Acatlán, Puebla
Burnished ceramic
22.5 × 28 × 31.7
1985/1.215

Bowls
Doña Rosa
San Bartolo Coyotepec, Oaxaca
Burnished blackware
17.5 × 15.2 (avg.)
1985/1.216 A–C

Donkey bank
Santa Cruz de las Huertas,
 Jalisco
Polychrome moldmade ceramic
22.5 × 20 × 19.2
1985/1.217

Bull bank
Santa Cruz de las Huertas,
 Jalisco
Polychrome moldmade ceramic
15.2 × 10 × 19.5
1985/1.218

Horse and rider
Provenance uncertain
Polychrome ceramic
12.5 × 12.5 × 8.2
1985/1.219

Female figures
Aguilar family
Ocotlán, Oaxaca
Polychrome incised ceramic
25 × 11.4 (avg.)
1985/1.220 A–D

Female figure
Aguilar family
Ocotlán, Oaxaca
Incised ceramic
25 × 11.4
1985/1.221

Basket
Puebla/Oaxaca(?)
Plaited palm fiber
29.3 × 25
1985/1.222

Basket
Oaxaca
Reed
17.5 × 20
1985/1.223

Duck candle holder
San Bartolo Coyotepec, Oaxaca
Burnished blackware
31.7 × 20
1985/1.224

Pig and armadillo figures
Doña Rosa
San Bartolo Coyotepec, Oaxaca
Burnished blackware
17.5 × 25 × 15.2
1985/1.225 A–C

Female figure
Doña Rosa
San Bartolo Coyotepec, Oaxaca
Burnished incised blackware
75 × 28 × 38.2
1985/1.226

73

Candle holder
San Bartolo Coyotepec, Oaxaca
Burnished blackware
29.3 × 18.5
1985/1.227

Doll
Teodora Blanco
Atzompa, Oaxaca
Buff ceramic with appliquéd
 decoration
86.5 × 28 × 30.5
1985/1.228

Doll
Teodora Blanco
Atzompa, Oaxaca
Buff ceramic with appliquéd
 decoration
89 × 38.2 × 33
1985/1.229

Dolls
Teodora Blanco
Atzompa, Oaxaca
Buff ceramic with appliquéd
 decoration
61 × 31 (avg.)
1985/1.230 A–C

Vase
Atzompa, Oaxaca
Glazed monochrome ceramic
22.5
1985/1.231

Miniature animals
Atzompa, Oaxaca
Ceramic
4.5 × 4.5 (avg.)
1985/1.232 A–C

Animal figures
Teodora Blanco
Atzompa, Oaxaca
Ceramic with appliquéd
 decoration
17.5 × 10 × 7.5 (avg.)
1985/1.233 A–E

Dolls
Teodora Blanco
Atzompa, Oaxaca
Ceramic with relief decoration
14 × 12.5 × 7.5 (avg.)
1985/1.234 A–C

Animal musicians
Teodora Blanco
Atzompa, Oaxaca
Ceramic
15.2 × 5 × 10 (avg.)
1985/1.235 A–E

Animal musicians
Teodora Blanco
Atzompa, Oaxaca
Ceramic
10 × 5 × 7.5 (avg.)
1985/1.236 A–D

Animal musicians
Teodora Blanco
Atzompa, Oaxaca
Glazed ceramic
17.5 × 20 (avg.)
1985/1.237 A–I

Animal musicians
Teodora Blanco
Atzompa, Oaxaca
Glazed ceramic
12.5 × 15.2 (avg.)
1985/1.238 A–I

Bird figures
Teodora Blanco
Atzompa, Oaxaca
Incised ceramic
11.4 × 11.4 (avg.)
1985/1.239 A–B

Duck figures
Teodora Blanco
Atzompa, Oaxaca
Incised ceramic
8.8 × 8.8 (avg.)
1985/1.240 A–B

Zoomorphic jar
Teodora Blanco
Atzompa, Oaxaca
Incised ceramic
19.5 × 19.5
1985/1.241

Vendors
Teodora Blanco
Atzompa, Oaxaca
Ceramic
20 × 15.2 × 12.5 (avg.)
1985/1.242 A–D

Dolls
Ocotlán, Oaxaca
Wood, feathers, cloth
33 (avg. h.)
1985/1.243 A–D

Skeleton with devils
Ocumicho, Michoacán
Varnished polychrome ceramic
38.2 × 21.5 × 22.5
1985/1.244

Cow driving truck
Ocumicho, Michoacán
Varnished polychrome ceramic
21.5 × 26.5 × 15.2
1985/1.245

Cathedral
Metepec, state of Mexico
Polychrome ceramic
63.5 × 33 × 30.5
1985/1.246

Three wise men
Soteno family
Metepec, state of Mexico
Polychrome moldmade ceramic
63.5 × 33 × 30.5 (avg.)
1985/1.247 A–C

Adam and Eve candelabra
Izúcar de Matamoros, Puebla
Varnished polychrome ceramic
56 × 48 × 15.2
1985/1.248

Mermaid figure
Metepec, state of Mexico
Incised ceramic
63.5 × 40.5
1985/1.249

Hat
San Cristobal de las Casas,
 Chiapas
Braided palm, ribbon
40.5 × 10
1985/1.250

Day of the Dead witch figure
Oaxaca
Polychrome wood, paper
14 × 6.5
1985/1.251

Rooster
State of Mexico
Tin
72.5 × 48
1985/1.252

Flowers
San Miguel de Allende,
 Guanajuato
Tin
25 (avg. h.)
1985/1.253 A–Q

Amate paintings
Francisco Garcia
Ameyaltepec, Guerrero
Water–based paint on *amate*
 (bark) paper
68.5 × 48
1985/1.254 A–B

Display cabinet
San Miguel de Allende,
 Guanajuato
Tin, glass
63.5 × 78.5 × 25
1985/1.255

Gourds
Provenance uncertain
Polychrome incised gourd
9.5 × 5
1985/1.256 A–B

Decorated candles
Provenance uncertain
Wax with applied wax
 decoration
30.5 × 15.2
1985/1.257 A–B

Lantern with lid
Uruapan, Michoacán
Lacquered polychrome gourd
34.2 × 25
1985/1.258

Fish figure
Olinalá, Guerrero
Lacquered polychrome gourd
48 × 8.2
1985/1.259

Bird figure
Olinalá, Guerrero
Lacquered polychrome gourd
40.5 × 35.5
1985/1.260

Powder box
Olinalá, Guerrero
Lacquered polychrome gourd
28 x 22.5
1985/1.261 A, B

Doll
Ameyaltepec, Guerrero, or
 Tolimán, San Agustin Oapan
Polychrome ceramic
46 × 15.2 × 10
1985/1.262

Pitcher
Tonalá, Jalisco
Burnished polychrome ceramic
25 × 17.5
1985/1.263

Bird figures
Olinalá, Guerrero
Lacquered polychrome gourd,
 wood
14 × 6.5 × 12.5 (avg.)
1985/1.264 A–B

Anthropomorphic mask
Michoacán
Polychrome carved wood
15.2 × 17.5
1985/1.265

Anthropomorphic mask
Michoacán
Polychrome carved wood
19 × 14
1985/1.266

Jar with lid
Guanajuato, Guanajuato
Glazed polychrome ceramic
25 × 22.5
1985/1.267 A–B

Talavera water bowl
Puebla
Glazed polychrome ceramic
36.5
1985/1.268

Plate
Dolores Hidalgo, Guanajuato
Glazed polychrome ceramic
14.5 (diam.)
1985/1.269

Bowl
Dolores Hidalgo, Guanajuato
Glazed polychrome ceramic
26.5 × 12.5
1985/1.270

Candelabra
Izúcar de Matamoros, Puebla
Varnished polychrome ceramic
48 × 43 × 15.2
1985/1.271

Platter
Patamban, Michoacán
Glazed monochrome ceramic
41.2 × 32.4
1985/1.272

Chest
Quiroga, Michoacán
Lacquered polychrome wood
33 × 63.5 × 38.2
1985/1.273

Chest
Olinalá, Guerrero
Lacquered polychrome wood
83.8 × 40.5 × 40.5
1985/1.274

Chest
Olinalá, Guerrero
Lacquered polychrome wood
38.2 × 78.5 × 46
1985/1.275

Chest
Olinalá, Guerrero
Lacquered polychrome wood
71 × 35.5 × 35.5
1985/1.276

Bank figures
Julián Acero
Santa Cruz de las Huertas,
 Jalisco
Polychrome moldmade ceramic
33 × 22.5 × 12.5 (avg.)
1985/1.277 A–E

Animal banks
Metepec, state of Mexico
Polychrome moldmade ceramic
24 × 22.5 × 10 (avg.)
1985/1.278 A–E

Fruit-bowl bank
Tlaquepaque, Jalisco
Polychrome moldmade ceramic
21.5 × 12.2
1985/1.279

Tortilla mold
Vizarón, Querétaro
Carved wood
29.3 × 24 × 3.6
1985/1.280

Pineapple jar
San Pedro Tlaquepaque, Jalisco
Glazed monochrome ceramic
63.5 × 38.2
1985/1.281 A–B

Plate
Tonalá, Jalisco
Burnished polychrome ceramic
50 (diam.)
1985/1.282

Fish bank
Provenance uncertain
Inlaid carved coconut shell
15.2 × 12.5
1985/1.283

Platters
Guanajuato, Guanajuato
Glazed polychrome ceramic
44.5 × 28 × 28 (avg.)
1985/1.284 A–D

Powder box
Uruapan, Michoacán
Lacquered gourd
21.5 x 21.5
1985/1.285 A, B

Machete and case
Guillermo Maldonado
Provenance uncertain
Horn, steel, tooled leather
78.5
1985/1.286

Sombrero
Provenance uncertain
Sewn braided fiber
53.3
1985/1.287

Boot pitcher
Barrio de la Luz, Puebla, Puebla
Glazed moldmade ceramic
28 × 24 × 12.5
1985/1.288

Candle holder
Isthmus of Tehuantepec, Oaxaca
Polychrome ceramic
17.5 × 11.4
1985/1.289

Bule (gourd)
Tonalá, Jalisco
Burnished polychrome ceramic
35.5 × 24
1985/1.290

Horse on wheels
Celaya, Guanajuato
Polychrome papier-mâché,
 wood
48 × 40.5 × 19
1985/1.291

Birdcage
Provenance uncertain
Reed
78.5 × 46 × 53.3
1985/1.292

Candelabra
Herón Martínez Mendoza
Acatlán, Puebla
Burnished ceramic
86.5 × 38.2
1985/1.293

Figure of Jesus
Aguilar family
Ocotlán, Oaxaca
Polychrome ceramic
76
1985/1.294

Female figure
Isthmus of Tehuantepec, Oaxaca
Ceramic
57 × 30.5
1985/1.295

Candelabra
Herón Martínez Mendoza
Acatlán, Puebla
Burnished ceramic
114.4 × 89 × 101.8
1985/1.296

Dolls
Teodora Blanco
Atzompa, Oaxaca
Ceramic
40.5 (avg. h.)
1985/1.297 A–B

Animal figures
Atzompa, Oaxaca
Glazed incised ceramic
10 × 10 × 5 (avg.)
1985/1.298 A–D

Flask
Tonalá, Jalisco
Burnished polychrome ceramic
24 × 17.5 × 7.5
1985/1.299

Vase
Oaxaca
Glazed monochrome ceramic
14 × 11.4
1985/1.300

Pitcher
Barrio de la Luz, Puebla, Puebla
Glazed polychrome ceramic
35.5 × 20 × 22.5
1985/1.301

Platter
Patamban, Michoacán
Glazed monochrome ceramic
33 × 5
1985/1.302

Globular jar
Oaxaca
Glazed ceramic
15.2 × 15.2
1985/1.303 A–B

Bowls
Jalisco
Glazed polychrome ceramic
12.2 × 25
1985/1.304 A–B

Plates
Tonalá, Jalisco
Glazed polychrome ceramic
28.2 × 2.5
1985/1.305 A–B

Plate
Metepec, state of Mexico
Varnished polychrome ceramic
23.3 × 2.5
1985/1.306

Toy whisk broom
Guanajuato, Guanajuato
Plaited plant fiber
50 × 7.5
1985/1.307

Ashtray
Ocotlán, Oaxaca
Burnished ceramic
6.5 × 14
1985/1.308

Candle holder
Michoacán
Drip-glazed ceramic
17.5 × 11.4 × 11.4
1985/1.309

Tortilla mold
Querétaro
Carved wood
3.6 x 12.5
1985/1.310

Figure of Virgin
Doña Rosa
San Bartolo Coyotepec, Oaxaca
Burnished blackware
28 × 22.5 × 12.5
1985/1.311

Dog bank
Santa Cruz de las Huertas,
 Jalisco
Varnished polychrome ceramic
24 × 26.5 × 10
1985/1.312

Lion bank
Julián Acero
Santa Cruz de las Huertas,
 Jalisco
Varnished polychrome ceramic
24 × 19 × 10
1985/1.313

Sombrero
Jalisco
Plant fiber, tooled leather
46 (diam.)
1985/1.314

Sombrero
Provenance uncertain
Braided plant fiber with
 embroidery
46 (diam.)
1985/1.315

Duck candle holder
Metepec, state of Mexico
Burnished blackware
20 × 22.5 × 15.2
1985/1.316

Retablo
Provenance uncertain
Oil on tin
34.8 × 24.5
1985/1.317

Retablo
Provenance uncertain
Oil on tin
33 × 25
1985/1.318

Retablo
Provenance uncertain
Oil on tin
32.4 × 25
1985/1.319

Incense burner
Izúcar de Matamoros, Puebla
Varnished polychrome ceramic
25 × 7.2
1985/1.320

Candle holder
Izúcar de Matamoros, Puebla
Varnished polychrome ceramic
33 × 22.5 × 14
1985/1.321

Jar
Tonalá, Jalisco
Burnished polychrome ceramic
40.5 × 38.2
1985/1.322

Huichol God's Eye
Nayarit
Yarn, wood
119.2 × 72.5
1985/1.323

Bowl
Guanajuato
Glazed polychrome ceramic
17 × 31.7
1985/1.324

Jar
Patamban, Michoacán
Glazed monochrome ceramic
19 × 22.5
1985/1.325

Bowl
Michoacán
Glazed monochrome ceramic
12.2 × 40.5
1985/1.326

Horse with rider
Celaya, Guanajuato
Polychrome moldmade papier
 mâché
24 × 24 × 8.8
1985/1.327

Flowers
Provenance uncertain
Foil paper
22.5
1985/1.328

Paper ornaments
Provenance uncertain
Foil paper
Various sizes
1985/1.329

Floral ornament with pin
Provenance uncertain
Molded Styrofoam
3.6 × 8.2 × 7.5
1985/1.330

Huichol *tabla*
Sierra de Nayarit, Nayarit
Yarn, beeswax on plywood
122 × 244.7
1985/1.331

Skirt
Acatlán, Guerrero
Embroidered wool
248 × 104
1985/1.332

Huipil (blouse)
Oaxaca
Embroidered cotton
110 × 91.5
1985/1.333

Huipiles (blouses)
Oaxaca
Embroidered cotton
Various sizes
1985/1.334 A–C

Sarape
Texcoco, state of Mexico
Woven wool
132.2 × 204
1985/1.335

Sarape
Provenance uncertain
Woven wool
193.7 × 173.2
1985/1.336

Gabán (man's outer garment)
State of Mexico
Woven wool
109 × 178.5
1985/1.337

Rebozo (shawl)
Provenance uncertain
Silk
43 × 160
1985/1.338

Rebozo (shawl)
Provenance uncertain
Silk
43 × 160
1985/1.339

Tarascan *rebozo* (shawl)
Michoacán
Cotton
43 × 160
1985/1.340

Belts
Provenance uncertain
Woven wool
Various sizes
1985/1.341 A–D

Bags
Provenance uncertain
Woven wool, looped sisal
Various sizes
1985/1.342 A–I

Runner
Provenance uncertain
Lace
68.5 × 28
1985/1.343

Table piece
San Luis Potosí
Lace
57.6 x 57.5
1985/1.344

Tablecloth
Provenance uncertain
Drawnwork on cotton
89 × 89
1985/1.345

Tablecloth
Michoacán
Drawnwork on cotton
75 × 75
1985/1.346

Blouse
Puebla/San Luis Potosí(?)
Lace
51 × 91
1985/1.347

Sarape
Hidalgo
Woven wool
219.2 × 124.5
1985/1.348

Mixe poncho
Oaxaca
Woven wool
203.6 × 76
1985/1.349

Sarape
Provenance uncertain
Embroidered sisal
68.5 × 94
1985/1.350

Bibliography

Abbreviations

CASART Casas de Artesanías
FONART Fondo Nacional para el Fomento de las Artesanías
INAH Instituto Nacional de Antropología e Historia
INI Instituto Nacional Indigenista
MNAIP Museo Nacional de Artes Populares
SEP Secretaría de Educación Pública
UNAM Universidad Nacional Autónoma de México

Alvarez, José Rogelio. *San Pedro Tlaquepaque*. Mexico: Enciclopedia de México, 1979.

American Federation of Art. *Mexican Arts*. New York: 1930.

Anawalt, Patricia Rieff. *Indian Clothing Before Cortés*. Norman: University of Oklahoma Press, 1981.

Atl, Dr. [Gerardo Murrillo]. *Las Artes Populares en México*. Mexico: Editorial Cultura, 1921.

_____. Mexico: La Secretaría de Industria y Comercio, 1922.

_____. Mexico: INI, 1980.

_____. *Antología de Textos Sobre Arte Popular*. Mexico: FONART-Fondo Nacional de Actualidades Sociales, 1982.

Becerril Straffón, Dr. Rodolfo. "La Importancia Económica y Social de las Artesanías." Presented at a seminar on the problems of folk art. Mexico: FONART-SEP, 1979.

Beke, Alice. "Exposition d'Art Populaire Mexicain." *Bulletin des Musées Royaux d'Art et d'Histoire* (Belgium) 3(1937): 2.

Best Maugard, Adolfo. *Tradición, Resurgimiento y Evolución del Arte Mexicano*. Mexico: Departamento Editorial de la Secretaría de Educación Pública, 1923. (2nd edition, Mexico: Editorial Viñeta, 1964.)

_____. "Del Origen y Peculiaridades del Arte Popular Mexicano." *Boletín de la Sociedad Mexicana de Geografía y Estadística* (1929).

Boggs, Ralph Steele. *Bibliografía del Folklore Mexicano*. Boletín Bibliográfico de Antropología Americana 3, no. 3. Mexico, 1939.

Bravo Ramírez, Francisco. *El Artesano en México*. Mexico: Editorial Porrúa, 1976.

Bricker, Victoria Reifler. *Ritual Humor in Highland Chiapas*. Austin: University of Texas Press, 1973.

Brown, Betty Ann. *Máscaras, Dance Masks of Mexico and Guatemala*. Bloomington: University Museums, Illinois State University, 1978.

Brody, J. J., et al. *Fiestas of San Juan Nuevo: Ceremonial Art from Michoacán, Mexico*. Albuquerque: University of New Mexico Press, 1942.

Carrillo, Rafael, and Teresa Pomar. *Artesano y Artesanías del Estado de México, México*. Mexico: Direccíon de Promoción Industrial, Comercial y Artesanal del Estado de México, 1973.

Caso, Alfonso. "La Proteccíon de las Artes Populares," *América Indígena* 2, no. 3(1942): 25–29.

_____. "¿Arte Mexicano o Arte en México?" *Indigenismo* (1958): 123–26.

_____. "El Arte Popular Mexicano," *México en el Arte* (1952): 87–100.

Castro, A.; A. Caso, M. Toussaint, M. Covarrubias, and R. Montenegro. *20 Centuries of Mexican Art*. New York: Museum of Modern Art, 1940.

Chase, Stuart. *Mexico: A Study of Two Americas*. New York: Macmillan, 1931.

Chicago Art Institute. *Mexican Art and Crafts: The Florence Dibell Bartlett Collection*. Chicago, 1936.

Cook de Leonard, Carmen. "Los Popolocas de Puebla." *Revista Mexicana de Estudios Antropológicos* 13 (1953): 423–45.

Cordry, Donald. *Mexican Masks*. Austin: University of Texas Press, 1980.

Cordry, Donald, and Dorothy Cordry. *Mexican and Indian Costumes*. Austin: University of Texas Press, 1968.

Covarrubias, Miguel. *Mexico South: The Isthmus of Tehuantepec*. New York: Knopf, 1947.

_____. *Obras Selectas del Arte Popular*. Mexico: MNAIP, 1953.

d'Harnoncourt, Rene. *Mexican Arts*. Portland, Maine: Southworth Press, 1930.

Dörner, Gerd. *Folk Art of Mexico*. New York: A. S. Barnes and Co., 1962.

Editorial Herrero, S.A. *Arte Popular Mexicano*. Mexico: 1975.

Edson, Gary. *Mexican Market Pottery*. New York: Watson Guptil, 1979.

Espejel, Carlos. *The Folk Arts of Mexico*. Tokyo: Heibonsha, 1971.

_____. *Las Artesanías Tradicionales en México*. Colección SEP-SETENTAS, no. 45. Mexico: Secretaría de Educación Pública, 1972.

_____. *Cerámica Popular Mexicana*. Spain: Editorial Blume, 1975. (Available in English, French, and Spanish.)

_____. *Olinalá*. Mexico: SEP-INI, 1976.

_____. "Artesanía y Arte Popular." In *Enciclopedia de México* 1 (1977): 436–46.

_____. *Artesanía Popular Mexicana*. Spain: Editorial Blume, 1977. (Available in English, French, and Spanish.)

_____. *Juguetes Mexicanos*. Mexico: SEP, 1981.

_____. "Rutas Artesanales del Estado de México," *Guía CASART*. Mexico: Gobierno del Estado de México, 1985.

_____. "¿Arte Popular o Artesanías?" In *Las Artes en México*, no. 11. Mexico: UNAM, 1986.

Esser, Janet Brody. *Faces of Fiesta: Mexican Masks in Context*. San Diego: San Diego State University, 1981.

Fernández, Justino. *Arte Mexicano, de Sus Orígenes a Nuestros Días*. Mexico: Editorial Porrúa, 1968.

Fernández, María Patricia. *El Arte del Pueblo Mexicano*. Mexico: UNAM, 1975.

Fernández Ledezma, Gabriel. *Juguetes Mexicanos*. Mexico: Talleres Gráficos de la Nación, 1930.

FONART-SEP. *I Seminario Sobre la Problemática Artesanal*. Mexico, 1979.

Fondo Editorial de la Plástica Mexicana. *The Ephemeral and the Eternal in Mexican Folk Art*. Mexico, 1971.

Foster, George M. "Contemporary Pottery Techniques in Southern and Central Mexico." In *Middle American Research Institute Publication 22*, 1–48. New Orleans, 1955.

Fournier, Robert. *Illustrated Dictionary of Practical Pottery*. New York, 1973.

Fox, Carl. *The Nelson A. Rockefeller Collection of Mexican Folk Art*. New York: Museum of Primitive Art, 1969.

Franco Fernández, Roberto. *El Folklore de Jalisco*. Guadalajara: Ediciones Kerigma, 1972.

González, José María. "Del Artesanado al Socialismo." SETENTAS, no. 163 (1974).

Graburn, Nelson H. H., ed. *Ethnic and Tourist Arts*. Berkeley: University of California Press, 1976.

Grove, Richard. *Mexican Popular Arts Today*. Colorado Springs: Taylor Museum, Colorado Springs Fine Arts Center, 1954.

Guzmán Contreras, Alejandro. "La Investigación del Arte Popular y las Artesanías." Presented at a seminar on the problems of folk art. Mexico: FONART-SEP, 1979.

Hernández, Francisco Javier. *El Juguete Popular en México: Estudio de Interpretación*. Mexico: Ediciones Mexicanas, 1950.

Hoag Mulryan, Leonore. *Mexican Figural Ceramists and Their Works*. Monograph Series, no. 16. Los Angeles: University of California Museum of Cultural History, 1982.

Hopkins, Barbara, and Florencia Müller. *A Guide to Mexican Ceramics*. Mexico: Editorial Minutiae Mexicana, 1979.

Horcasitas, Fernando. "Mexican Folk Art." *National Geographic* 153, no. 5(May 1978): 648–69.

Horcasitas de Barros, María Luisa. *Una Artesanía con Raíces Prehispánicas en Santa Clara del Cobre*. Colección Científica Etnología 97. Mexico: INAH.

Huitrón, Antonio. *Metepec, Miseria y Grandeza del Barro*. Mexico: Instituto de Investigaciones Sociales, UNAM, 1962.

Instituto Nacional de Estadística, Geografía e Informática. *Estadísticas Históricas de México*. 2 vols. Mexico: SEP-INAH, 1985.

Instituto Nacional Indigenista. *Bibliografía de las Artes Populares Plásticas de México*. Mexico: Memorias del INI, 1950.

————. *Arte Popular de México*. Mexico: La Revista Artes de México, 1963.

Jenkins, Katherine D. "Lacquer." In *Handbook of Middle American Indians* 6, ed. Robert Wauchope, 125–37. Austin: University of Texas Press, 1967.

Johnson, Irmgard W. *Design Motifs on Mexican Indian Costumes*. Graz: Akademische Druck, 1976.

Kojin, Ioneyama. *The Popular Arts of Mexico*. New York and Tokyo: Weatherhill and Heibonsha, 1974.

Kubler, George. "On the Colonial Extinction of the Motifs of Pre-Columbian Art." In *Essays in Pre-Columbian Art and Archaeology*, ed. Samuel K. Lothrop, 14–34. Cambridge, Mass.: Harvard University Press, 1964.

Lackey, Louana M. *The Pottery of Acatlán: A Changing Mexican Tradition*. Norman: University of Oklahoma Press, 1982.

Lechuga, Ruth D. *El Traje Indígena de México*. Mexico: Panorama Editorial, S.A., 1982.

Marín de Paalen, Isabel. *Historia General del Arte Mexicano: Etno-Artesanías y Arte Popular*. Mexico: Editorial Hermes, 1974.

————. *Historia general del arte Mexicano etno-artesanias y arte popular*. Mexico: Editorial Hermes, S.A., 1976.

Marquéz Ayala, David. "El Financiamiento a la Actividad Artesanal." Presented at a seminar on the problems of folk art. Mexico: FONART-SEP, 1979.

Martínez del Rio de Redo, Marita, et al. *El Rebozo*. Mexico: Artes de México, 1971.

Martínez Peñaloza, Porfirio. *Arte Popular y Artesanías Artísticas en México*. Mexico: Secretaría de Hacienda y Crédito Público, Ediciones del Boletín Bibliográfico, 1972.

————. *Popular Art of Mexico: The Artistic Creativity of the Mexican People Throughout Time*. Mexico: Ediciones Lara, S.A., 1979.

————. *Tres Notas Sobre el Arte Popular en México*. Mexico: Miguel Angel Porrúa, 1980.

Mather, Christine. *Baroque to Folk*. Santa Fe: Museum of New Mexico Press for the Museum of International Folk Art, 1980.

McAllister, Linda. *Arbol de la Vida: The Ceramics of Metepec*. San Diego: Founders Gallery, University of San Diego, 1983.

Méndez, Leopoldo, et al. *Lo efímero y eterno del arte popular mexicano*. 2 vols. Mexico: Fondo Editorial de la Plástica Mexicana and Banco Nacional de Comercio Exterior, S.A., 1971, 1974.

Mingei International Museum. *Vivan los Artesanos! Mexican Folk Art from the Collection of Fred and Barbara Meiers*. La Jolla, California, 1980.

Montenegro, Robert. "Museo de Artes Populares." *Colección Anahuac de Arte Mexicano* 6(1948).

Moya Rubio, Victor José. *Máscaras: La Otra Cara de México*. Mexico: Universidad Nacional Autónoma de México, 1978.

————. *Máscaras Mexicanas. Exposition of the Museo Nacional de Antropología*. Mexico: Imprenta Madero, 1974.

Museo Nacional de Culturas Populares. *El Universo del Amate*. Mexico, n.d.

Novelo, Victoria. *Artesanía y Capitalismo en México*. Mexico: SEP-INAH, 1976.

————. "La Produccíon de Artesanías en México." Presented at a seminar on the problems of folk art. Mexico: FONART-SEP, 1979.

Panyella, August, ed. *Folk Arts of the Americas*. New York: Harry N. Abrams, 1981.

Paz, Octavio. *Labyrinth of Solitude: Life and Thought in Mexico*. New York: Grove Press, Inc., 1961.

Petit, Florence H., and Robert M. Petit. *Mexican Folk Ways: Festival Decoration and Ritual Objects*. New York: Hastings House, 1978.

Pomar, María Teresa. *Danza-Máscara y Rito-Ceremonía*. Mexico: FONART, 1982.

Ricard, Robert. *The Spiritual Conquest of Mexico*. Trans. L. B. Simpson. Berkeley: University of California Press, 1966.

Romero de Terreros y Vinent, Manual. *Las Artes Industriales en la Nueva España*. Mexico: Librería de Pedro Robredo, Col. el Arte en México, 1923.

Rubín de la Borbolla, Daniel. *Arte Popular Mexicano*. Mexico: Fondo de Cultura Económica, Archivo del Fondo, 1974.

_____. "Conservación, Protección y Fomento de las Artesanías." Presented at a seminar on the problems of folk art. Mexico: FONART-SEP, 1979.

_____, et al. "Arte Popular." *Artes de México*, no. 43/44 (1962).

Ruis, Eugenia C. de, ed. *Arte Popular de México*. Mexico: Artes de Mexico and INI, 1963.

Santiago, Federico. *Fiestas in Mexico*. Mexico: Ediciones Lara, S.A., 1978.

Sayer, Chloe. *Crafts of Mexico*. New York: Doubleday, 1977.

Starr, Frederick. *Catalogue of a Collection of Objects Illustrating the Folklore of Mexico.* Publications of the Folklore Society. Wiesbaden, 1898. (Nendeln: Kraus Reprint, 1967).

Terán, Silvia. *Artesanías de Yucatán*. Mérida: Dirección General de Culturas Populares, SEP, 1981.

Thiele, Eva-María. *El Maque*. Morelia: Instituto Michoacano de Cultura, 1982.

Toneyama, Korin. *The Popular Arts of Mexico*. New York: John Weatherhill, Inc., 1974.

Toor, Frances. *A Treasury of Mexican Folkways*. New York: Crown, 1947.

_____. *Mexican Popular Arts*. U.S.A.: Blaine Ethridge Books, 1975.

Valenzuela Rojas, Bernardo. *Artesanías Artísticas de Oaxaca*. Chile: Editorial Universitaria, 1964.

Villegas, Victor Manuel. *Arte Popular de Guanajuato*. Mexico: Banco Nacional de Fomento Cooperativo, S.A., 1964.

Whitaker, Irwin. *A Potter's Mexico*. Albuquerque: University of New Mexico Press, 1978.

The Mexican Museum